Country French

Florals & Interiors

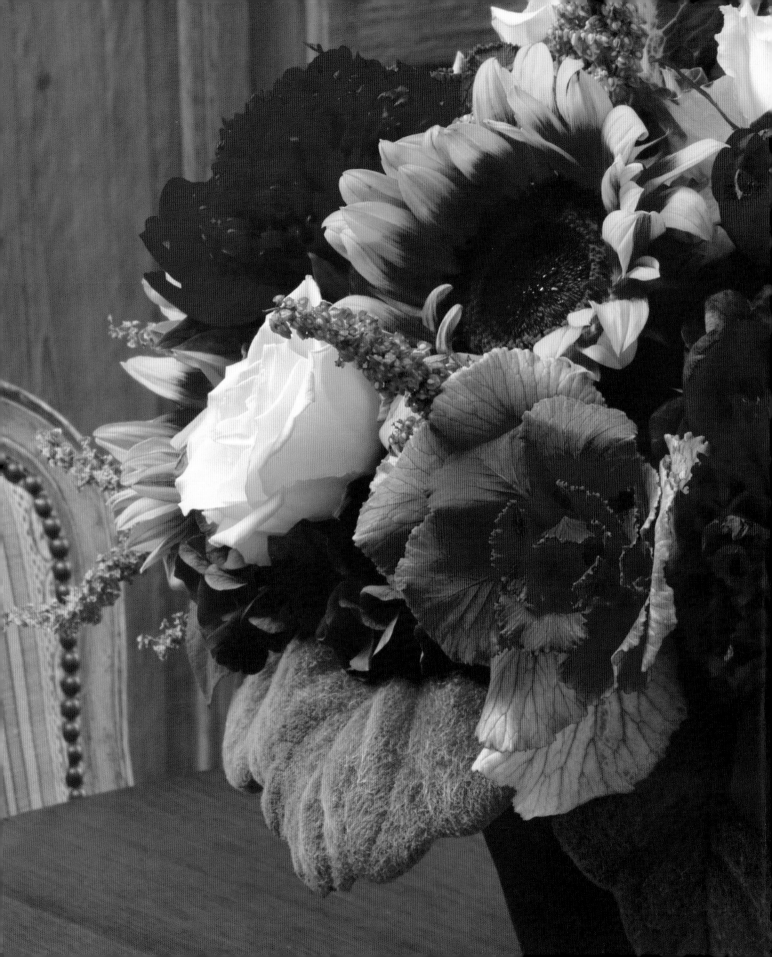

CHARLES FAUDREE

Country French
Florals & Interiors

with TONI GARNER
and Francesanne Tucker photographs by Rick Stiller

Gibbs Smith, Publisher
TO ENRICH AND INSPIRE HUMANKIND
Salt Lake City | Charleston | Santa Fe | Santa Barbara

First Edition
12 11 10 09 08 6 5 4 3 2

Published by
Gibbs Smith, Publisher
P.O. Box 667
Layton, Utah 84041

Orders: 1.800.835.4993
www.gibbs-smith.com

Designed by Debra McQuiston
Printed and bound in China

Library of Congress Cataloging-in-Publication Data
Faudree, Charles.
 Country French florals & interiors / Charles Faudree,
with Toni Garner ;
text by Francesanne Tucker ; photographs by Rick Stiller.
— 1st ed.
 p. cm.
 ISBN-13: 978-1-4236-0329-0
 ISBN-10: 1-4236-0329-X
1. Floral decorations. 2. Flower arrangement.
3. Decoration and ornament, Rustic—France—Influence.
I. Garner, Toni. II. Tucker,
Francesanne. III. Stiller, Rick. IV. Title. V. Title: Country
French florals and interiors.

SB449.F37 2008
745.92—dc22

 2007046319

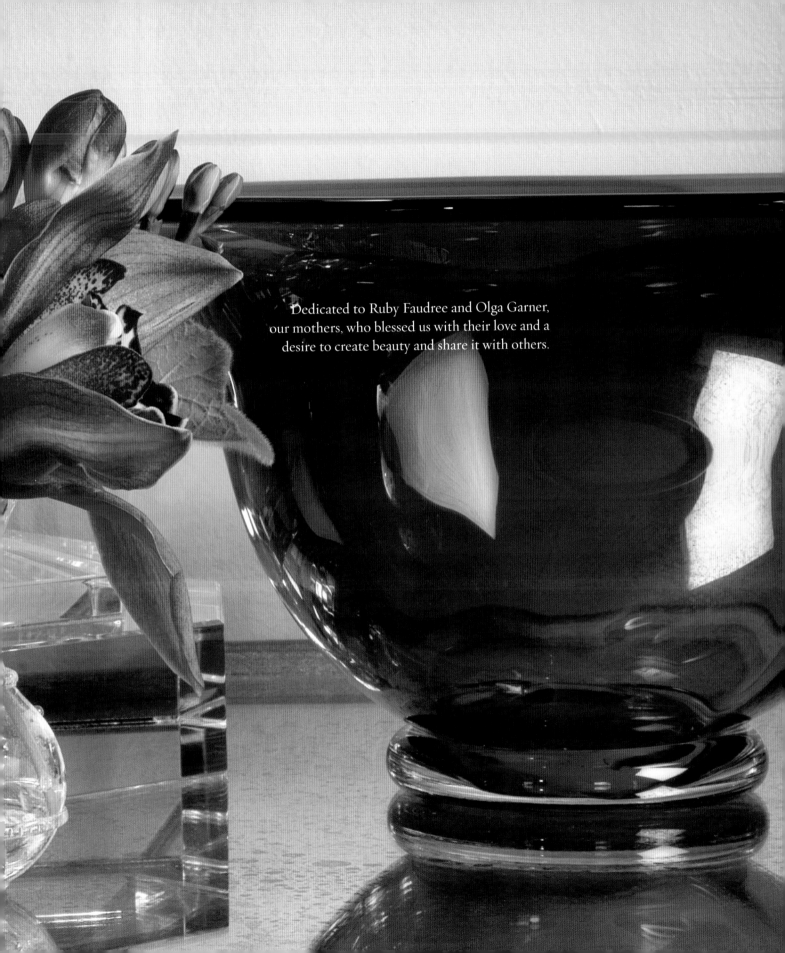

Dedicated to Ruby Faudree and Olga Garner,
our mothers, who blessed us with their love and a
desire to create beauty and share it with others.

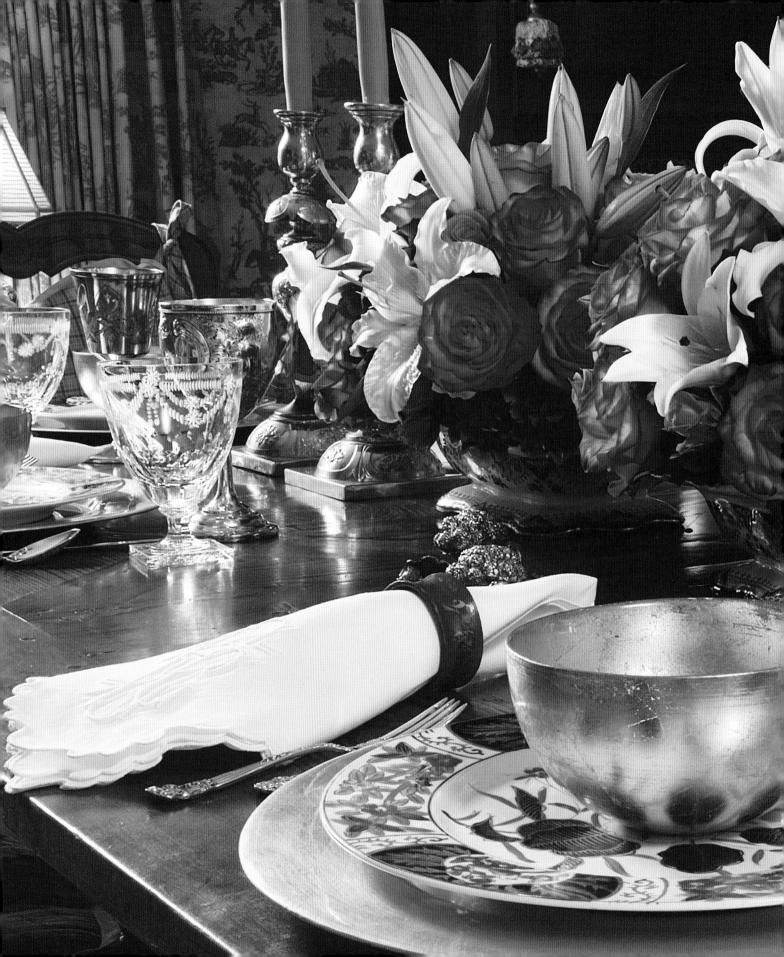

Contents

The timeless style of Country French has always been my first love. It can be elegant, warm, easy or formal. Its many moods give me the freedom to express my own design philosophy.

I compare this style to the relationship between a simple French farmhouse and an elegant château. Both share the sun-dappled colors of Provence's countryside, and their very different traditions create a wonderful mix. From rustic woods to gilded bergère chairs, Fortuny silks to linen checks, the many aspects of Country French combine to create a welcoming atmosphere that can be dressed up or down to suit individual preference.

My rule book for creating with Country French is to forget the rules. Floral fabrics

It may come as a surprise, then, that I believe the ultimate accessories are fresh flowers, which can't be collected or saved at all.

My grandmother showed me the importance of accessorizing with flowers. As a child, I helped her with her cutting garden—rows and rows of different varieties of flowers that she grew to cut and enjoy indoors. Her bouquets were living accessories, constant reminders of the bright colors and carefree happiness of summer.

That early experience taught me that flowers belong in good decorating. They breathe life into a room. Quite simply, they are the icing on the cake.

The icing for the interior designs in this book is provided by my florist and friend, Toni Garner. She has an amazing gift and shares my

Vive la Difference!

do belong with plaids . . . and stripes. Painted woods—my favorite, faux finishes, and mellow old pines—all have their place. Contemporary pieces can work, too, adding a modern edge to a design.

While throwing out the rule book, there is one rule I always keep. I always use accessories. They are the most important part of my decorating. As I've moved from house to house over the years, I've changed fabrics and furnishings many times, but my accessories—and especially my collections—stay with me.

I've been collecting accessories all my life, and they aren't necessarily French. I started when I was in college, buying English Staffordshire as gifts for my sister, Francie. One of my own collections, Napoleonic memorabilia, is very French, but it mixes nicely with my cherished Chinese export plates and my dog figures.

lifelong love of flowers. She has created the arrangements for all my Tulsa homes that have been featured in decorating books, magazines and my own books.

The natural talent Toni is blessed with was brought home to me on a recent trip to France. When in Paris, I always go by the Left Bank shop of legendary florist Christian Tortu. When I saw the fabulous arrangement in his display window, my first thought was, "Oh, my gosh, they're knocking off Toni!"

Toni shares my belief that flowers are the single most important accessory. She also shares my design credo: It's all about the mix, not the match. In this volume she demonstrates both, guiding you in the how's, where's and why's that will help you create your own masterpieces with flowers.

—*Charles Faudree*

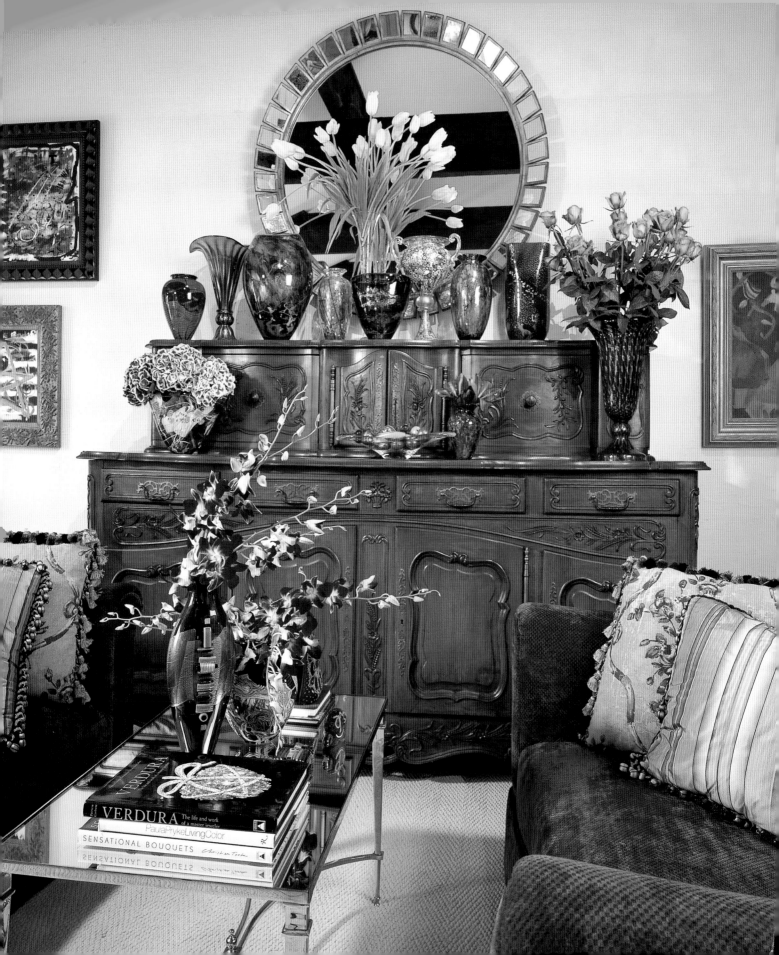

Like Charles, my passion for flowers goes back to my childhood. My grandmother and aunt both had flower shops. Flowers were everywhere. As a child, I thought everyone had bouquets in every room of their house.

From a bright spring tulip for my teacher to my first teenage corsage, I remember the highlights of my growing up years in terms of flowers. One of my earliest memories is of my grandfather's birthday. There was an enormous cake in the center of the table, surrounded by flowers. There was singing and happiness and love in my family, and the cake and its magical floral garland captured the wonder of that day for me.

One of the most important things I've learned is that flower arrangements are not static accessories. They have a life cycle, much like the flowers in a garden. Evolving over time, from the promise of opening buds to the scattered petals at the base of a

Les Fleurs!

mature bouquet, each day in the life of a wonderful floral presentation brings new pleasure.

Flower arrangements can have added importance if thought is given to their holder. While I love to use a client's favorite vase, I also look for a special container they may have, something not originally intended to be a vase. A cherished antique biscuit box, a Chinese bowl, or even a child's antique wheelbarrow can make the flowers it holds more charming.

Because flowers add so much to our lives, I would like to urge you to think of them as a necessity. Stopping by your florist shouldn't be limited to special occasions. You can give yourself real pleasure by picking up a single blossom. I take one home every day. When I travel, the first thing I do is to get flowers for my hotel room. My friends go shopping; I head for the florist.

I am honored that Charles has given me the opportunity to participate in this book, and I am grateful for the chance to share with you some of the things I've learned during my privileged life working with flowers.

—*Toni Garner*

"CELEBRATE
THE HAPPINESS THAT FRIENDS
ARE ALWAYS GIVING ..."

—Amanda Bradley

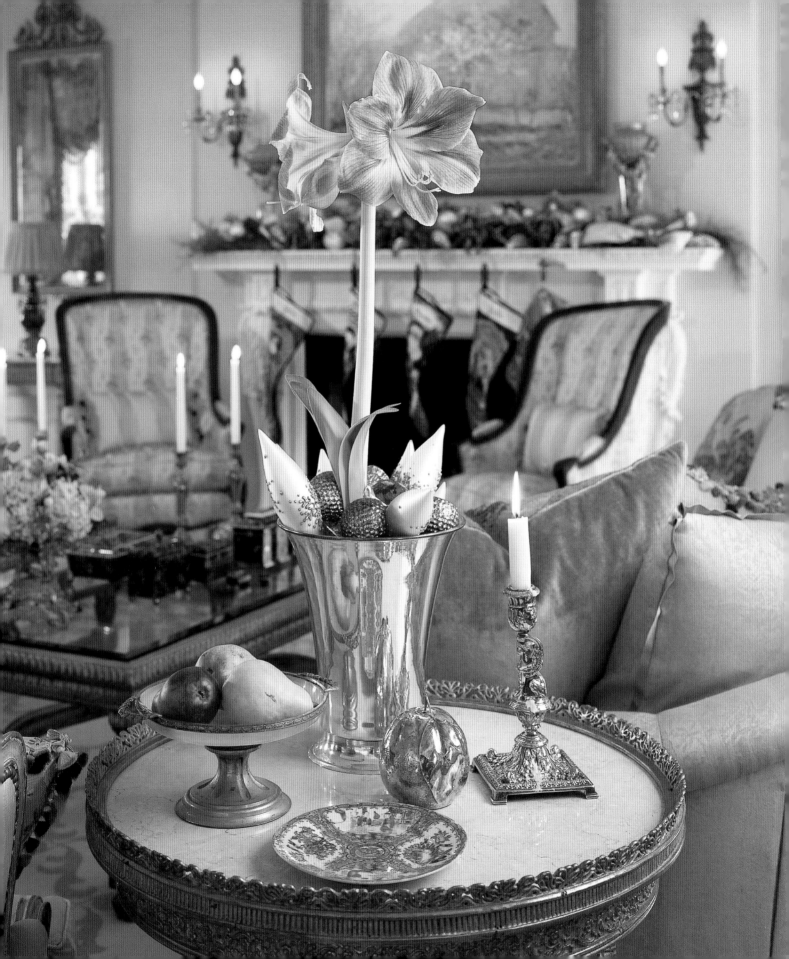

I LOVE DECORATING for all kinds of celebrations. The first thing I do when I plan a party is to apply my decorating philosophy—it's all about the mix, not the match—to my guest list. A good mix of people leads to interesting conversation and humor that can make anyone look like a great host. Then the only thing left to do is create an atmosphere that encourages a festive evening.

Good friends, delicious food and beautiful flowers are enough. But if you create a theme for your party, the extra effort adds to everyone's enjoyment. Garden parties are a good example. A country garden theme might include checked tablecloths, pails of sunflowers, seed packet place cards and garden trowel serving spoons. A sophisticated garden theme could start with stately topiaries, silver candelabra and tennis whites.

Celebrations

Holiday celebrations practically plan themselves. Berries, holly and plenty of red ribbon are Christmas-party staples. Think pink and hearts for Valentine's Day. And spooky cobwebs, dripping candles and black napkins spell Halloween.

My love of celebrations probably comes from my early experiences giving parties when I lived in Muskogee, Oklahoma. We didn't have the opera or theatre companies or a symphony to attend, so we created our own entertainment. We went all out for birthday parties, holiday parties and no-reason-at-all parties. By far the most successful, and still my favorite today, are costume parties.

Encouraging your guests to come in costume lets everyone share in the fun of decorating. One party that I'll never forget was an Academy Awards party where everyone dressed as their favorite nominee. The winner, Hannibal Lecter (my friend, Nancy Ingram), arrived carried on a board, bound in a straitjacket and wearing a baseball catcher's mask. That was an evening to remember!

—*Charles*

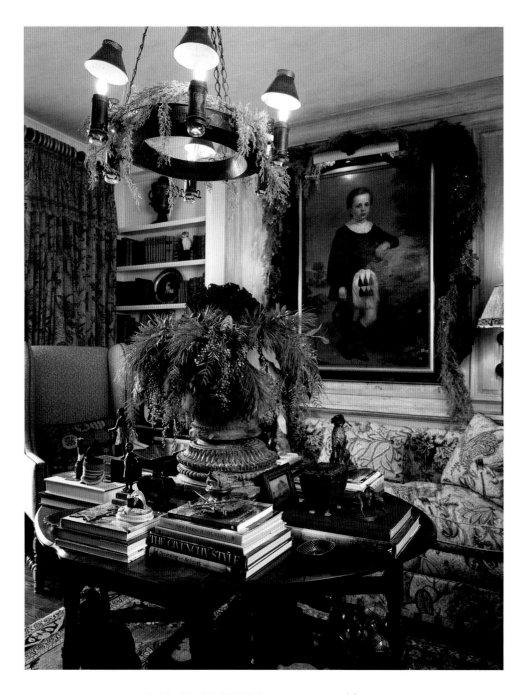

A GARLAND OF WINTER greens woven with tartan
ribbon and red roses got its inspiration from the fabric and color depicted in one of Charles's
favorite paintings, *above*. An English gateleg table holds the stunning living
still life. Toni used cascading winter greens, holly and pepperberries in an antique terra-cotta
urn crowned with an orb of red roses, *facing*.

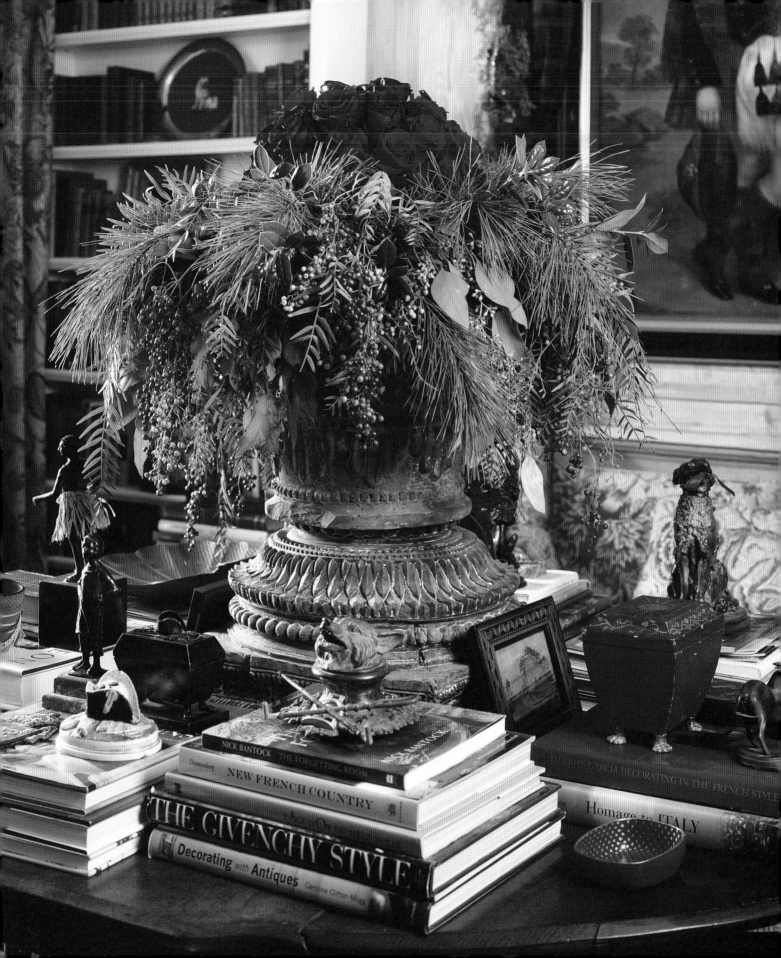

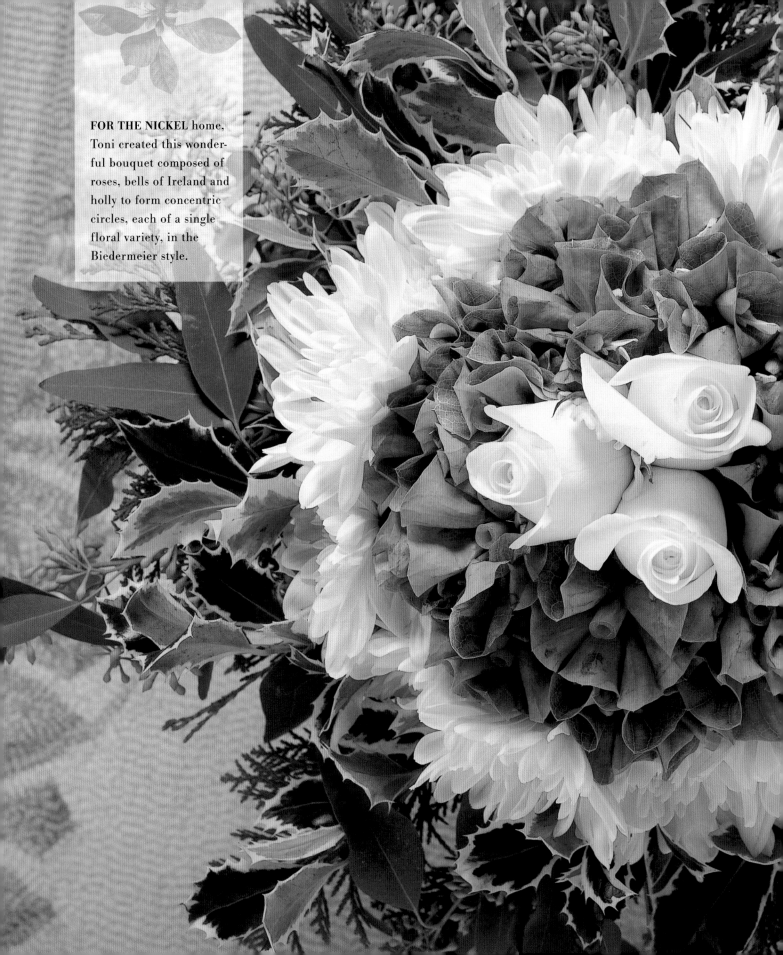

FOR THE NICKEL home, Toni created this wonderful bouquet composed of roses, bells of Ireland and holly to form concentric circles, each of a single floral variety, in the Biedermeier style.

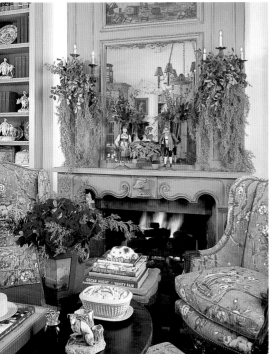

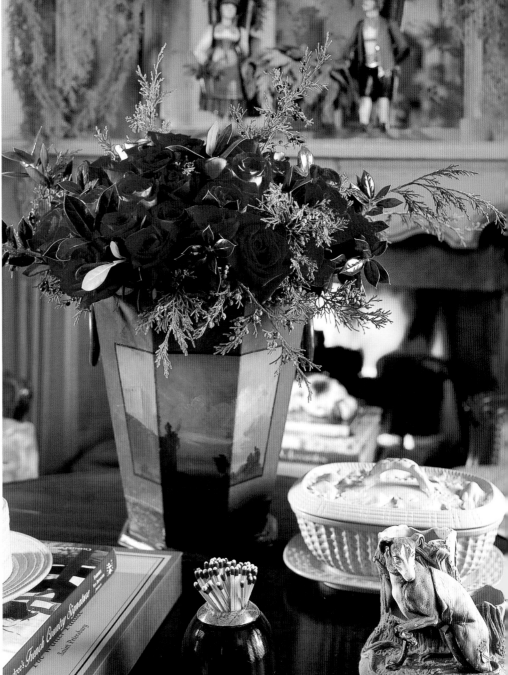

CHARLES'S EXTENSIVE COLLECTIONS offer a cornucopia of vase possibilities.
For this mantel design, Toni selected a zinc leaf bouquet and a pair of tole French Provençal
santos bearing a holiday harvest of holly, ilex berries and red roses.
Greenery and berries festoon the flanking sconces, *left*.
A vase from his tole collection is topped with holiday greenery and red roses, *above*.

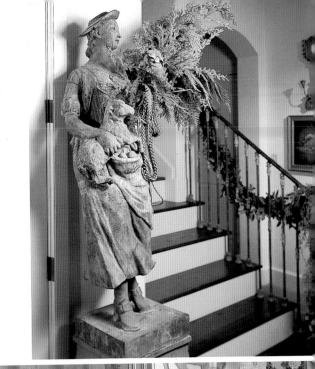

IN CHARLES'S entry, a lead shepherdess with lambs also bears a sheaf of holiday greenery, *right*. A French buffet holds a wonderful example of an arrangement used to underscore interior design. Toni uses a miniature antique French wheelbarrow as a charming and unexpected container for winter greenery to lead the eye into the Italian landscape painting above it. A pair of antique iron pigeons completes the pastoral scene, *below*.

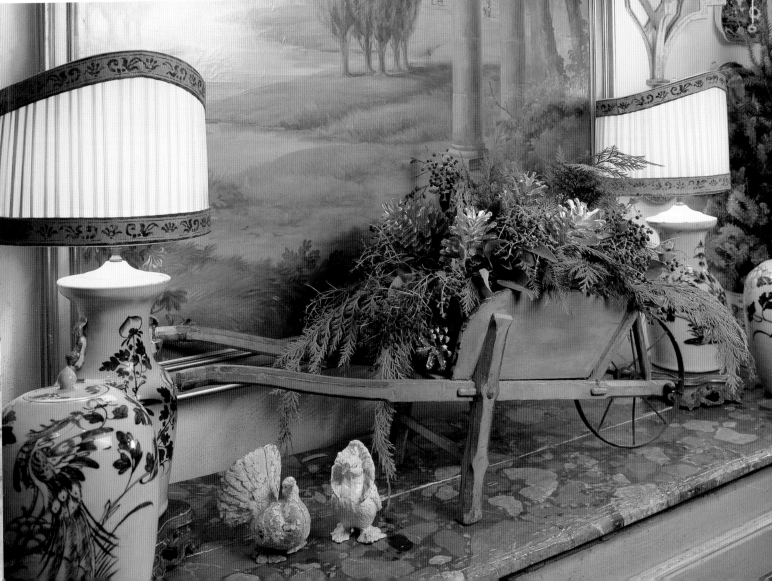

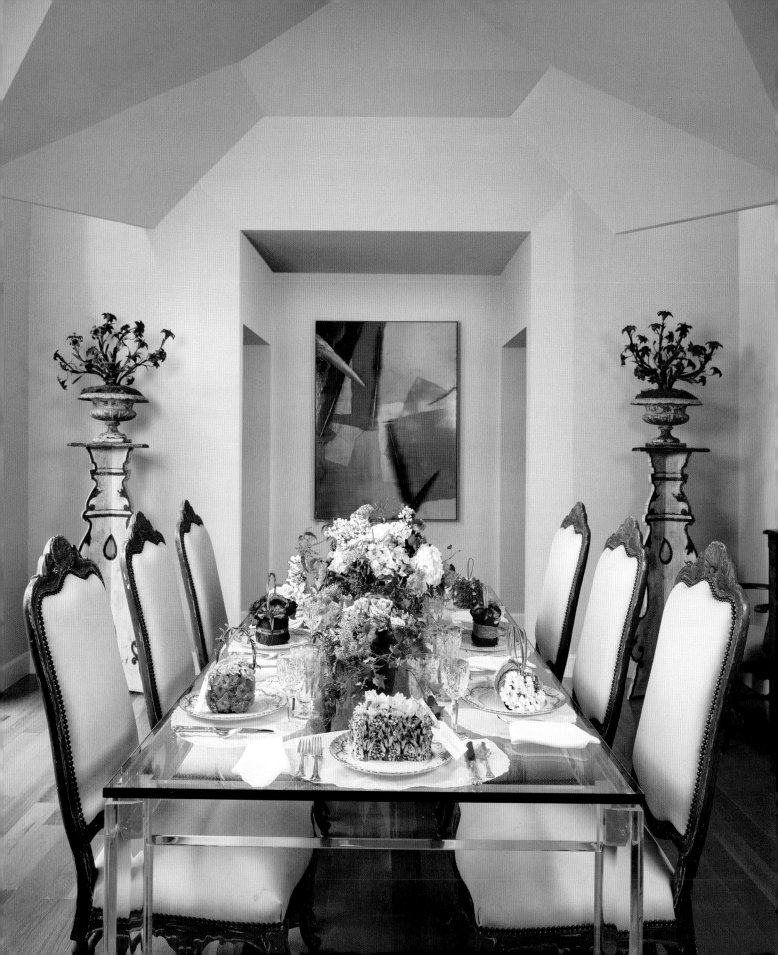

Dressing the Dining Room

The hardest decision to make when you plan a celebration isn't where to start; it's where on earth to stop! A pretty centerpiece on the table might be enough (keep in mind that guests should be able to easily see over it or around it, not have to bob and weave to get a glimpse of someone across the table). But you can extend the floral ambiance in a variety of ways, from flower-wrapped votives to an edible-flower first course.

For any of these endeavors, your florist is a great inspiration and resource, but you can also get a lot of pleasure doing things on your own. Here are some possibilities:

•Flowers can be used to accent a plate or completely surround it. The sky's the limit: you can even create a floral canopy above the table.
• Simple vases, each holding a flower of a different variety, can be spaced the length of the table to create an elegant but easy centerpiece.
• A long-stemmed rose or tulip lying across each plate can highlight your china.
• Small nosegays can double as place cards or party favors or both.
• Flower-and-ivy napkin ring creations can lend an exquisite touch.

These are just a few ideas before you even consider decorating guest-of-honor chairs or mantels or chests.

For holiday entertaining, I love to raid my garden (or a friend's) for evergreen branches. Creative pruning can yield bundles of holly, boxwood, berries and magnolia leaves. I fill vases and cache pots all over my house. I also use this evergreen harvest to weave swags and garlands and wreathes. I tell my clients not to hesitate: head for the garden with your shears. Plants, particularly boxwood, benefit from the removal of some interior branches to improve air circulation. And, of course, you will reap the reward of surplus winter greenery.

—Toni

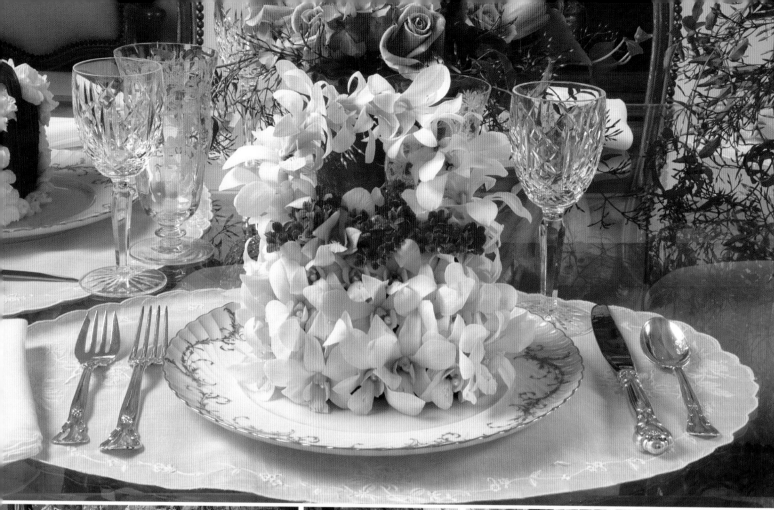

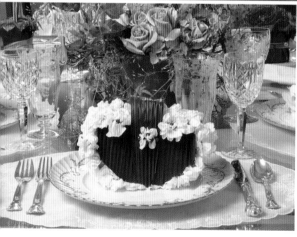

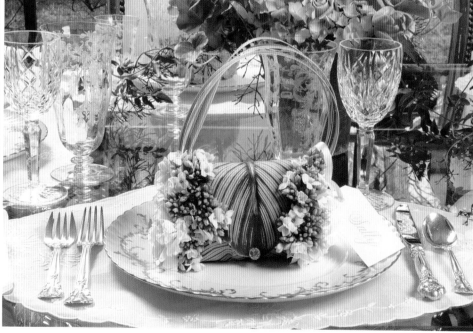

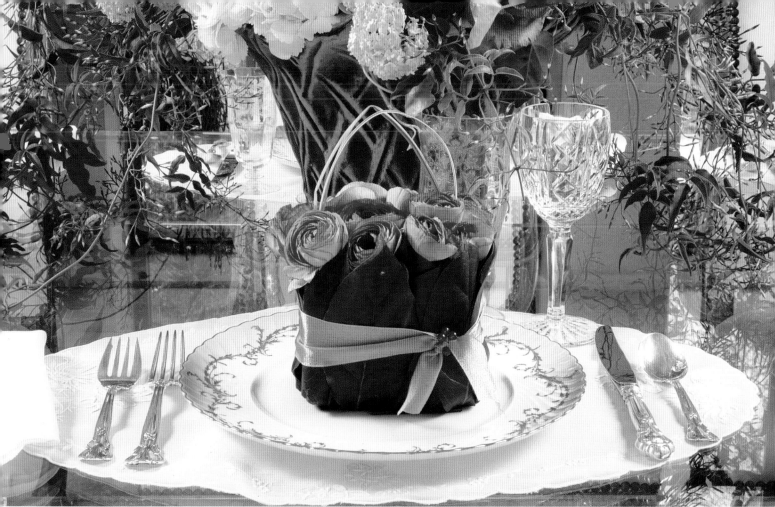

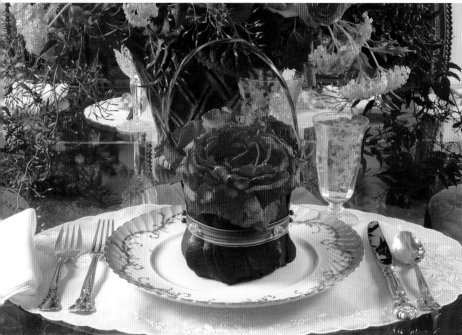

FLOWERS CAN create the theme for a celebration, as Toni illustrates here for a Ta-Ta Sisterhood birthday honoring Francie Faudree. The ladies of the birthday group arrived in their own hats and Toni provided each an exquisite floral "purse" as a favor from the hostess. Carol Pielsticker. Tags attached to the handles of the purses with silk ribbon serve as place cards.

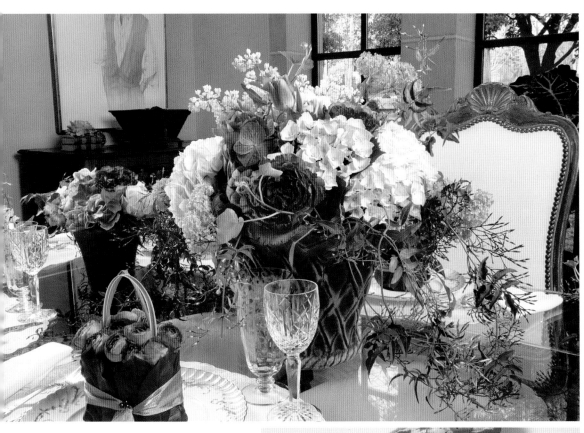

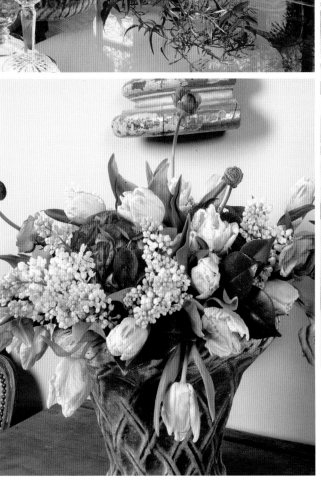

CLOUDS OF PINK and white flowers adorn terra-cotta pot centerpiece and sideboard bouquets, *above* and *right*. The Pielsticker dining room showcases a contemporary glass and acrylic table and Italian-style chairs upholstered in butter leather. A pair of painted Portuguese plant stands support antique bronze bouquets, *facing*.

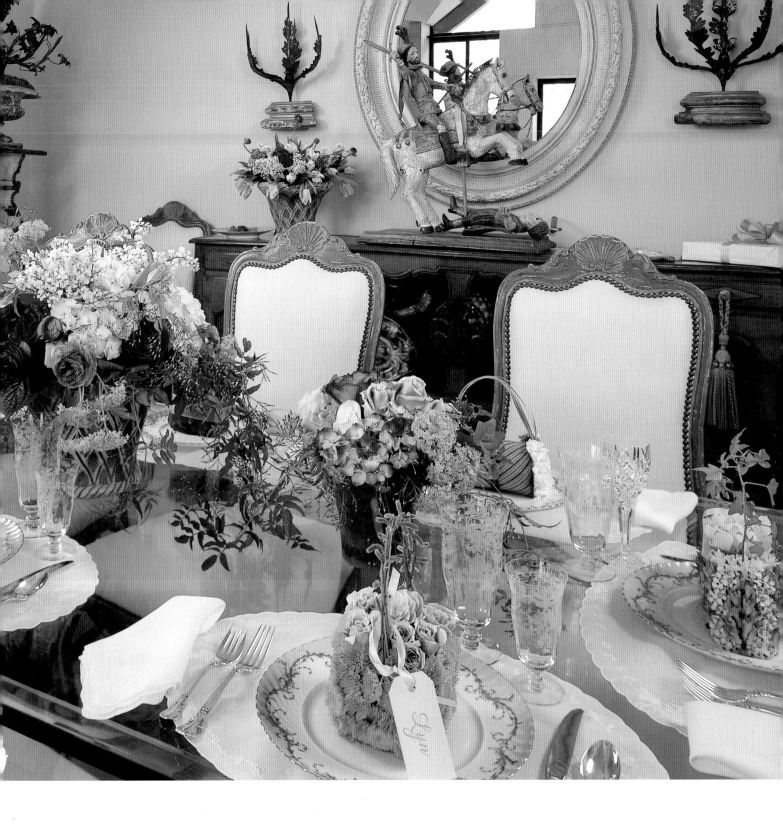

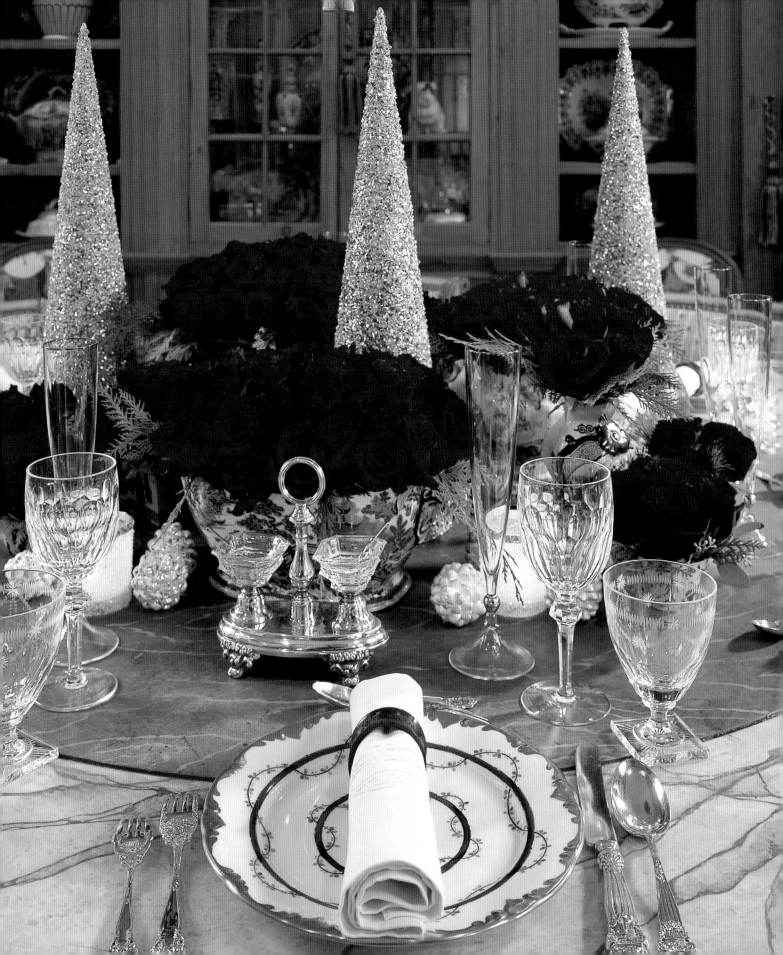

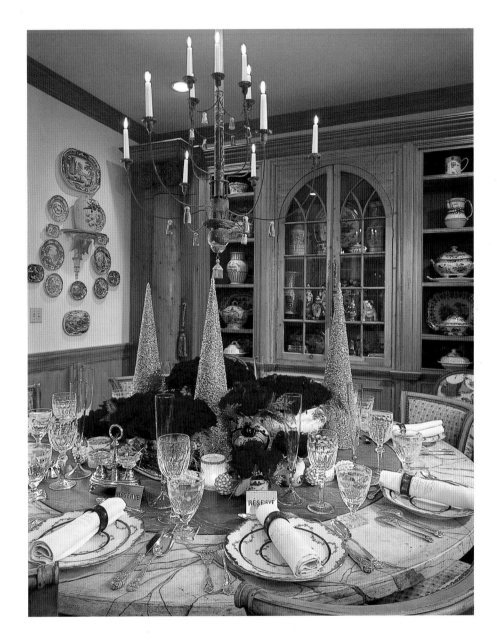

FOR CHARLES'S HOLIDAY DINNER,
a faux bois-and-marble table forms a delightful contrast to the elegant place
settings of Sevres china, Christofle silver and William Yeoward
crystal, *facing*. An English pine breakfront lines an entire wall, while an antique French
chandelier adds charm with its lighted candles. Beneath jeweled Christmas "trees,"
Toni added masses of red roses to accent blue-and-white footbaths and
part of Charles's beloved collection of Chinese export jars and vases, *above*.

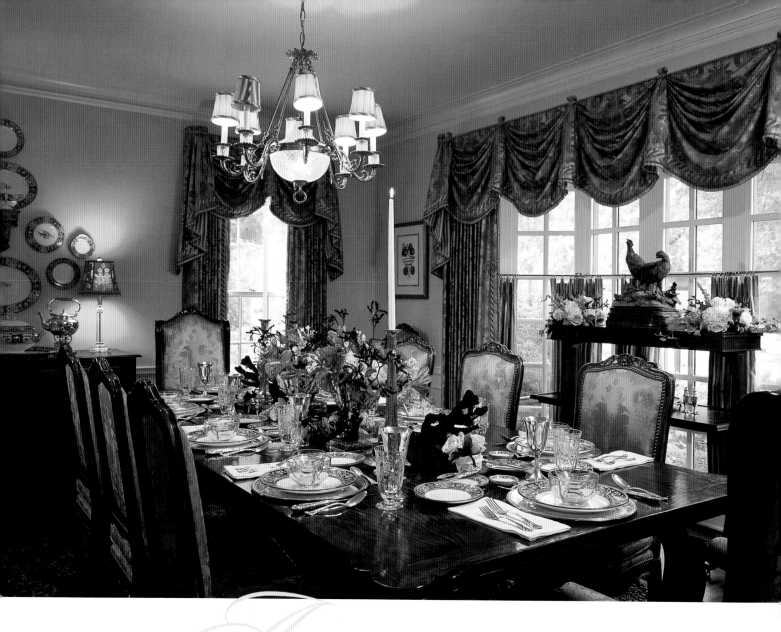

A STUNNING floral theme not only set the mood but also dictated the menu for a dinner party in Francesanne and John Tucker's home. Seafood was preordained when Toni used coral to complement the color in the Fortuny fabric and inherited Minton china. She expanded the seaside concept with a prodigious scattering of shells, vases with a coral design, and Oceana roses. Centerpiece flowers included coral-colored anthurium, kangaroo paw (a floral look-alike for coral), white hydrangea and variegated pittosporum the color of sea foam.

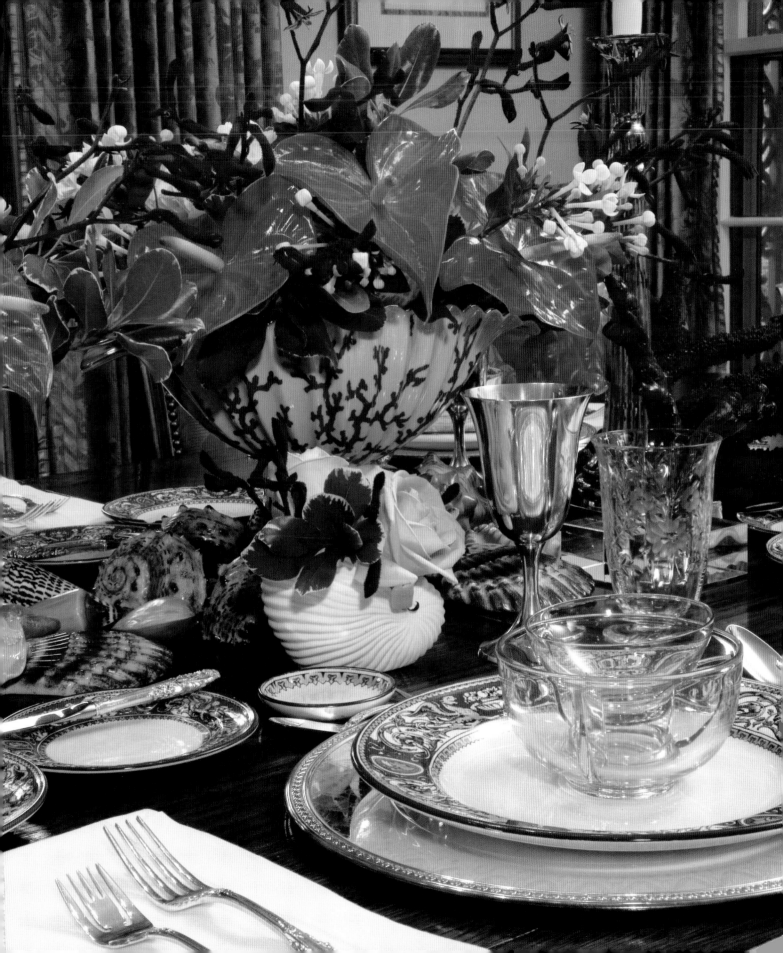

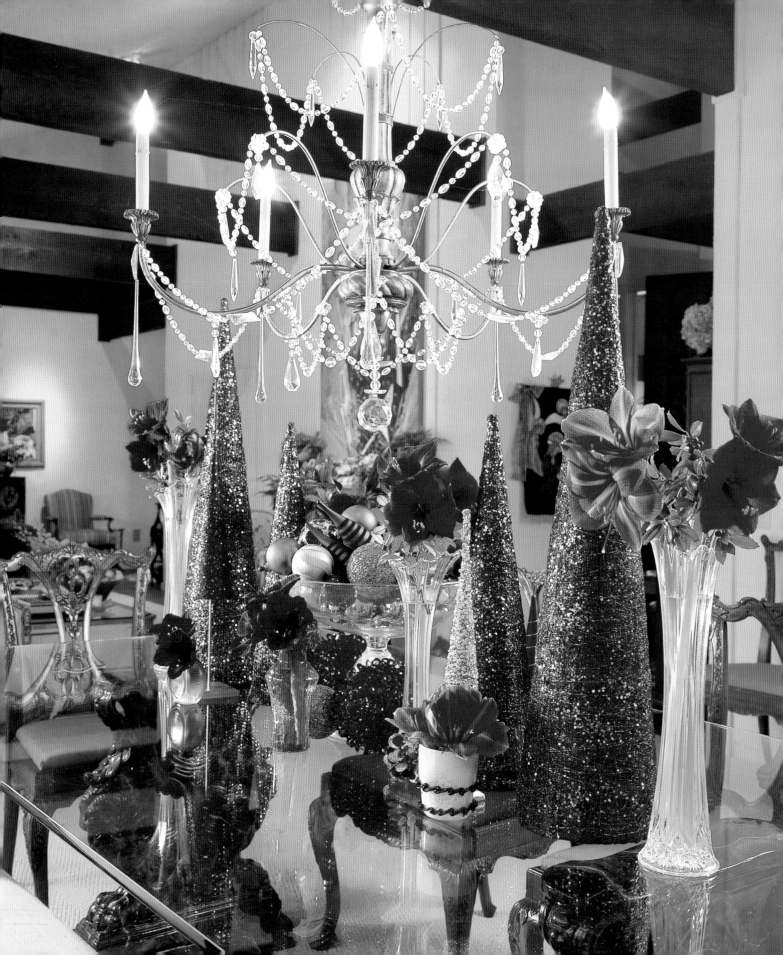

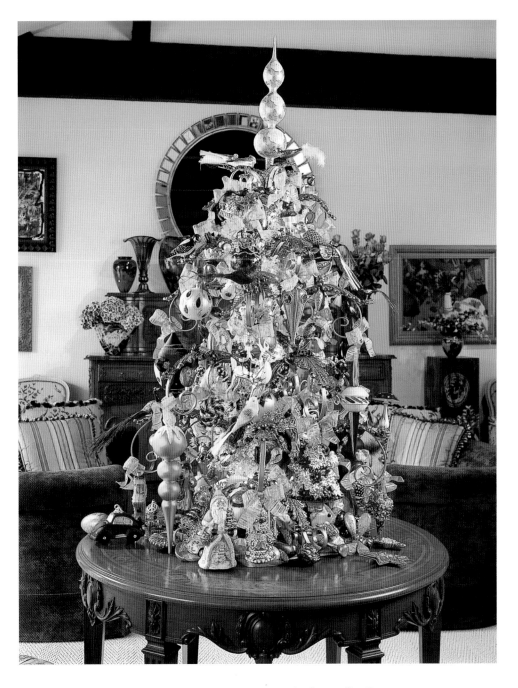

CHRISTMAS IS A RAINBOW of colors at Toni's.
The dining table displays red and purple jeweled "trees" and red amaryllis in antique and art
glass vases. Toni's Christmas tree overflows with colorful ornaments.

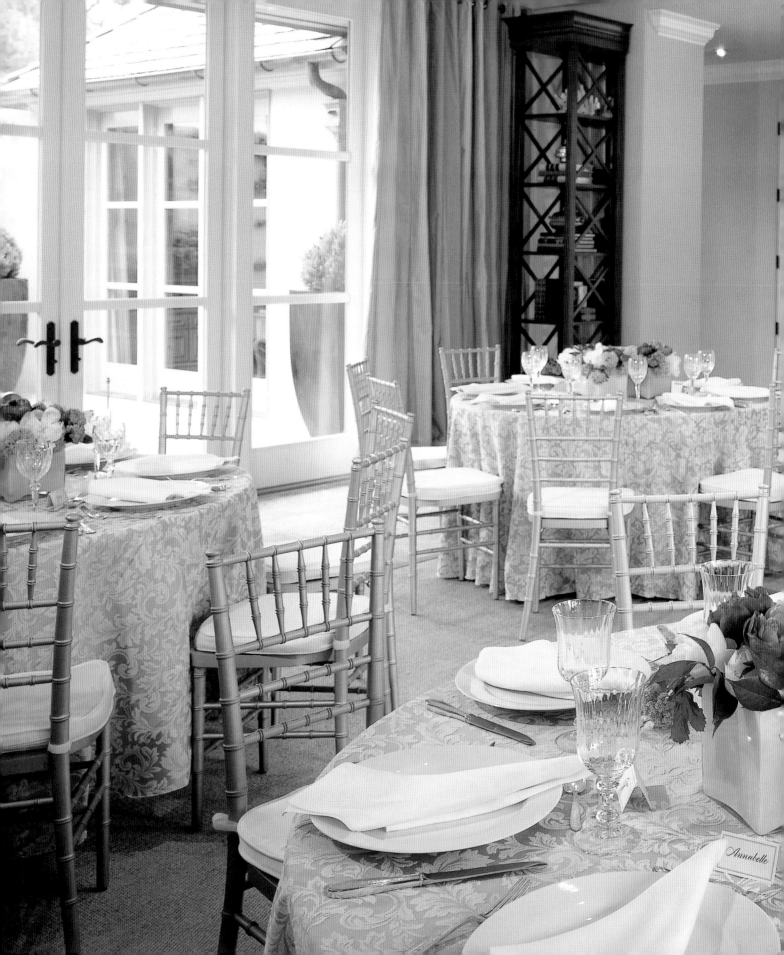

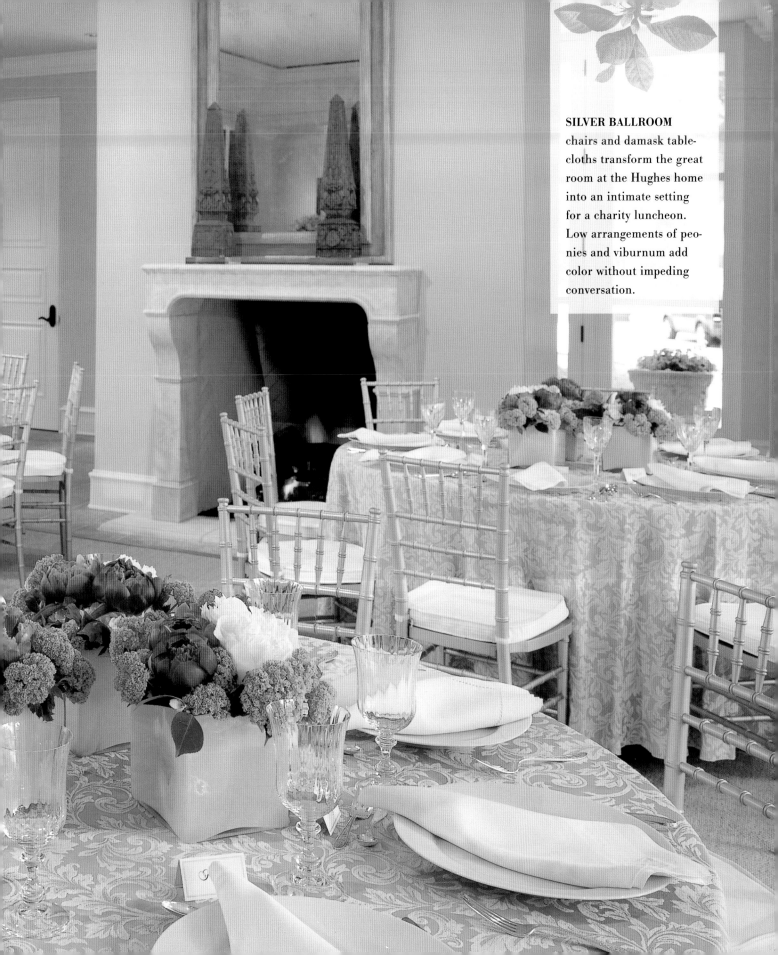

SILVER BALLROOM chairs and damask tablecloths transform the great room at the Hughes home into an intimate setting for a charity luncheon. Low arrangements of peonies and viburnum add color without impeding conversation.

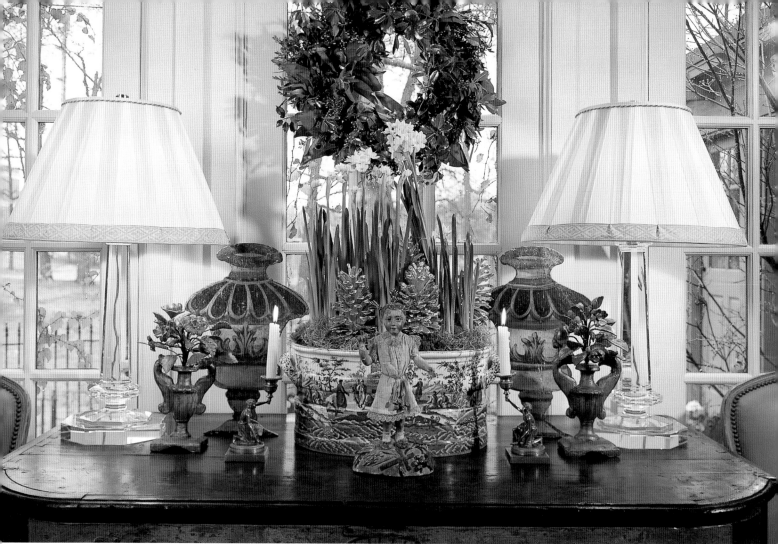

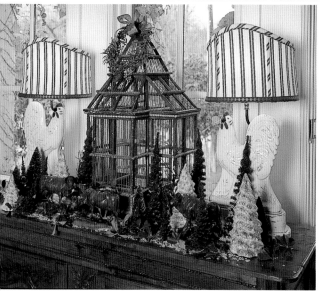

CHARLES'S FAVORITE saint, an antique Spanish santo, is featured in a Christmas composition of paperwhite narcissus and gilded pinecones beneath a gilded wreath of seeded eucalyptus, *above*. Toni creates a bucolic "village" for the French buffet. Rare antique Staffordshire rooster lamps become part of the scene that includes a wreath-topped antique bird cage, Black Forest carved cows and Charles's collection of miniature holiday trees, *left*. Long-lived winter greenery is practical as well as artistic. Here, mixed winter greenery and boxwood frame an antique Regency bull's-eye mirror. The sole survivor of an antique crèche rests beneath, *facing*.

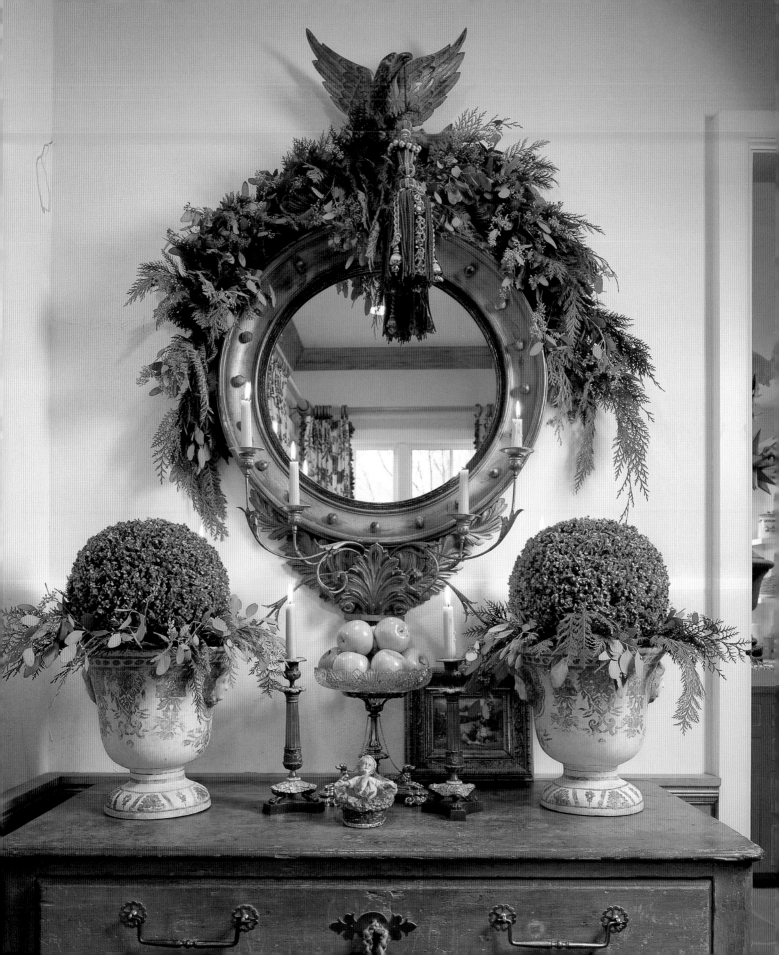

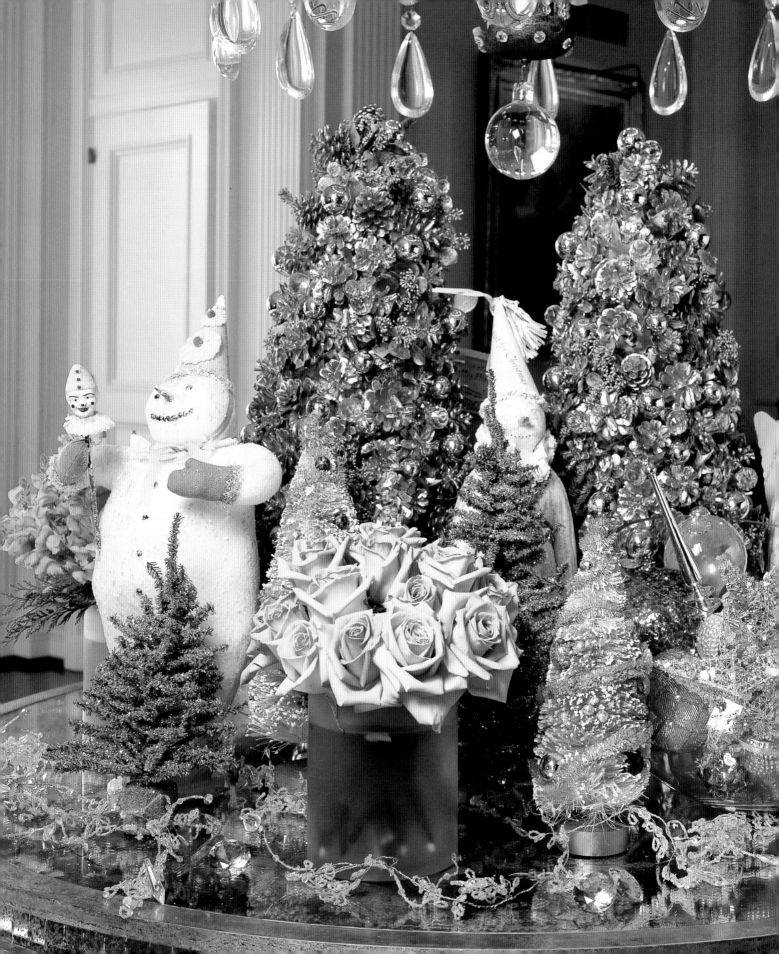

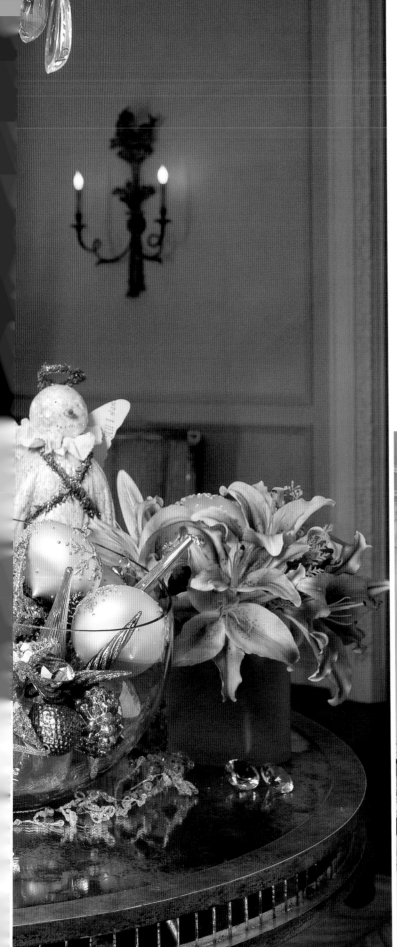

FOR CHRISTMAS, Toni creates a table arrangement in the Nickels entry that is both sophisticated and humorous. 'Katrina' roses and Oriental lilies punctuate an assortment of sparkling miniature trees and cheery snowmen. Adding to the magic are treasured ornaments displayed in a glass bowl instead of on the typical tree, *left*. A center table by Niermann Weeks and carved gilt stools from Grandeur echo the architectural elegance of the Nickels entrance hall. Beaded crystal chandelier by Alan Knight, *below*.

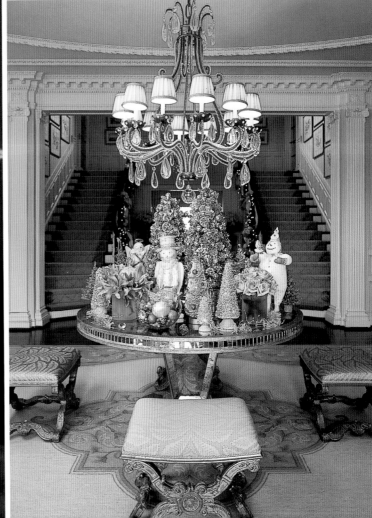

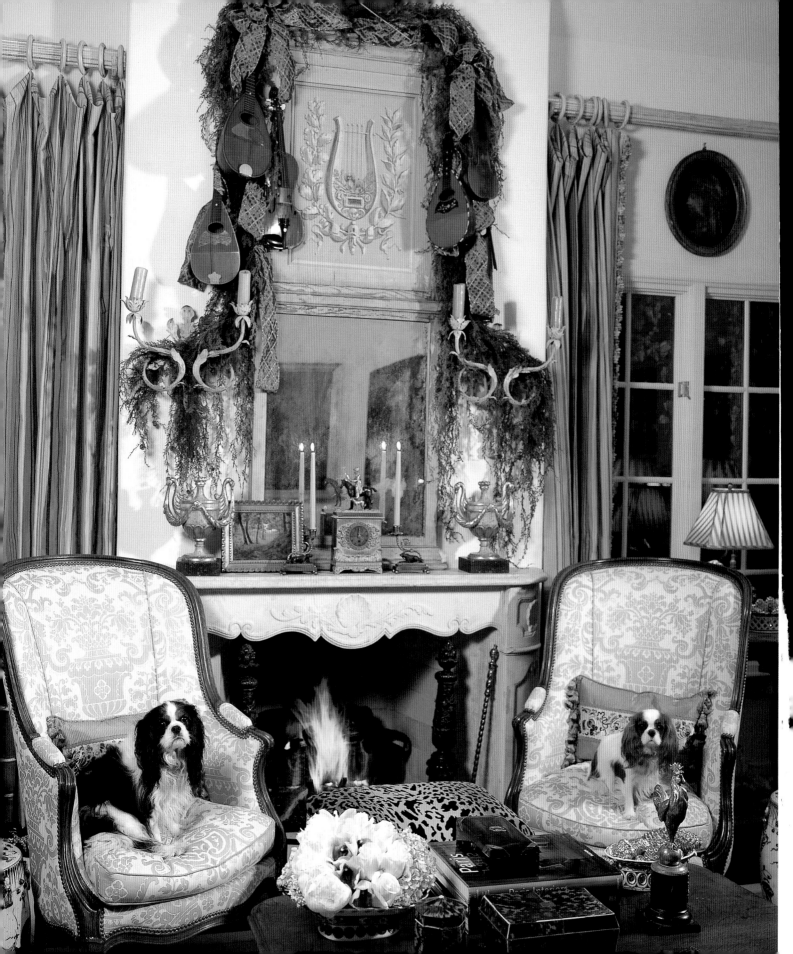

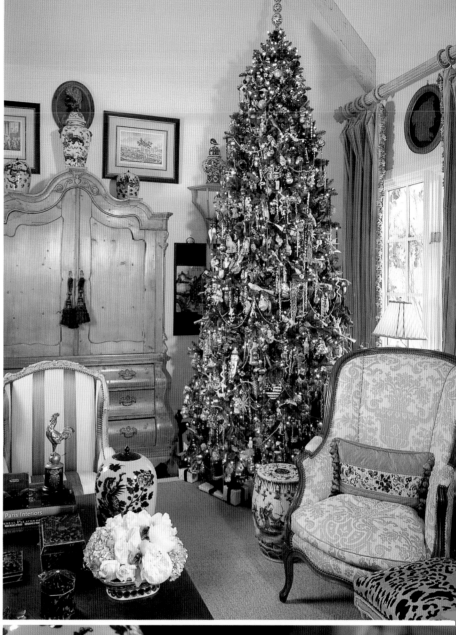

CHARLES AND TONI collaborate to fill his home with celebration during the holidays. A swag of fresh winter greenery adorned with a collection of antique violins and mandolins repeats the musical theme of the lyre carving on the mirror. Nicholas and Ruby, the penultimate Faudree accessories, enjoy the fire from a pair of Louis XV bergères à la reine (queen's armchairs) c. 1750, *facing*. A stately blue spruce is scarcely visible beneath the wealth of Charles's Christmas ornaments. The armoire is an eighteenth-century Dutch piece, *above right*. A bowl from Charles's Chinese export collection holds a pavé (dense, showing no leaves) bouquet of hydrangeas, roses, orchids and peonies. *below right*.

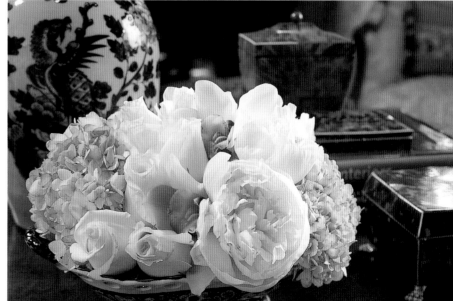

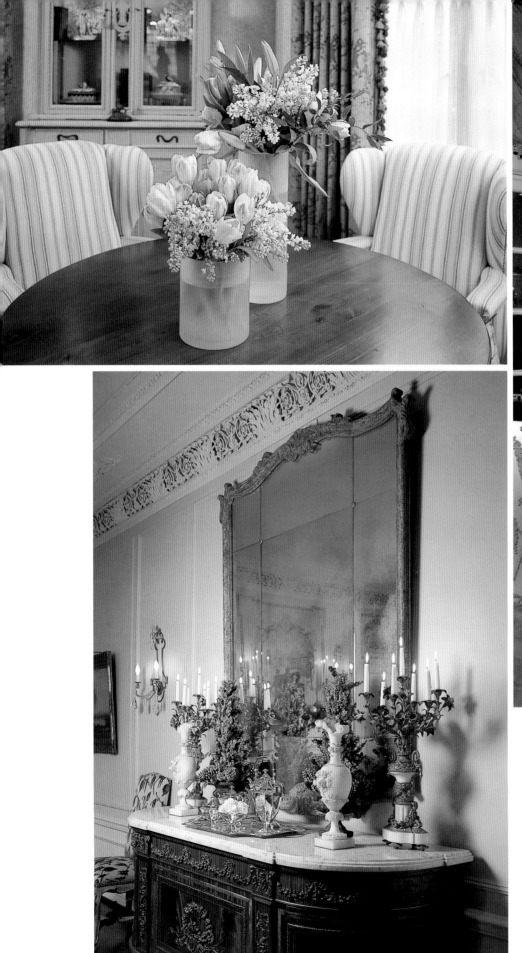
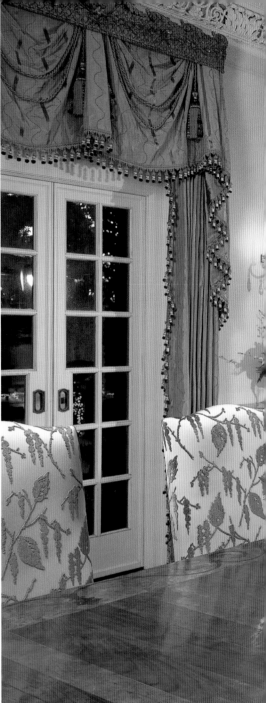

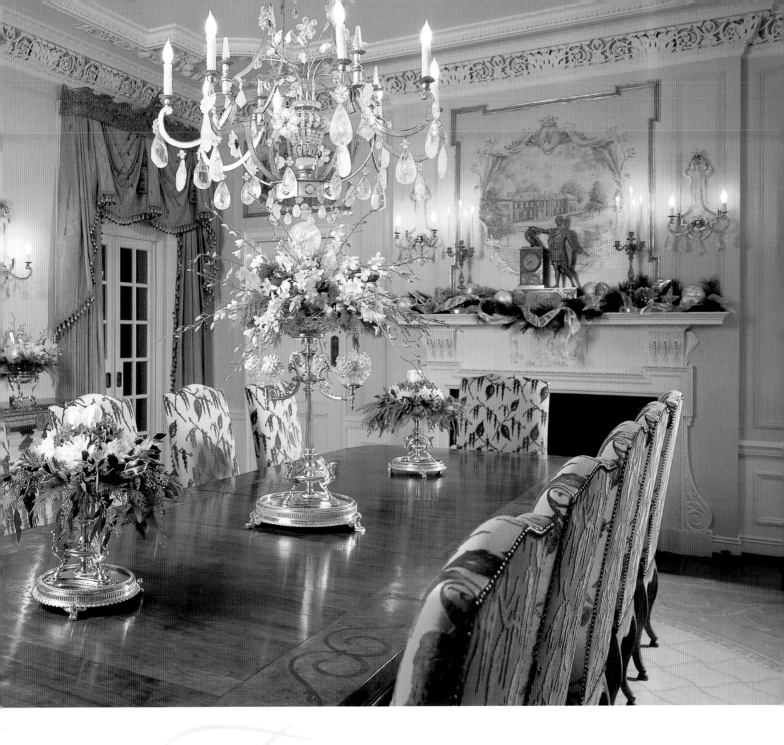

THE RALPH LAUREN muted
stripes on the game chairs are
picked up by frosted vases of
pastel flowers, *facing above*.
The Belle Epoch gilt bronze
enfilade supports marble and
ormolu candelabra. A white

rose nosegay and miniature
evergreen trees add a holiday
touch, *facing below*. The gran-
deur of the Nickels' dining
room is reflected in its furnish-
ings, including a Louis XV
rock crystal chandelier and

chairs from the same period.
The table is topped with clas-
sic epergnes filled with white
orchids, roses and winter
mums. At the end of the
room is a Georgian painted-
wood fire surround, *above*.

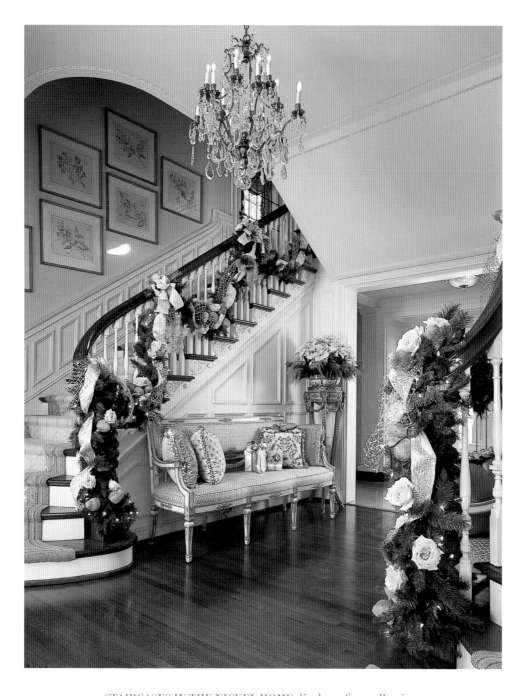

STAIRCASES IN THE NICKEL HOME display a fine collection
of hand-colored engravings, "Hortus Indicus," from *Hortus Malabaricus*, published
in Amsterdam c. 1678. A pair of Swedish settees is from Minton Spidell's "Cluny" collection.
The antique chandelier is from David Denham, *above*. Evergreen garlands with ribbon and
creamy 'Message' roses adorn the staircases in the Nickel home, *facing*.

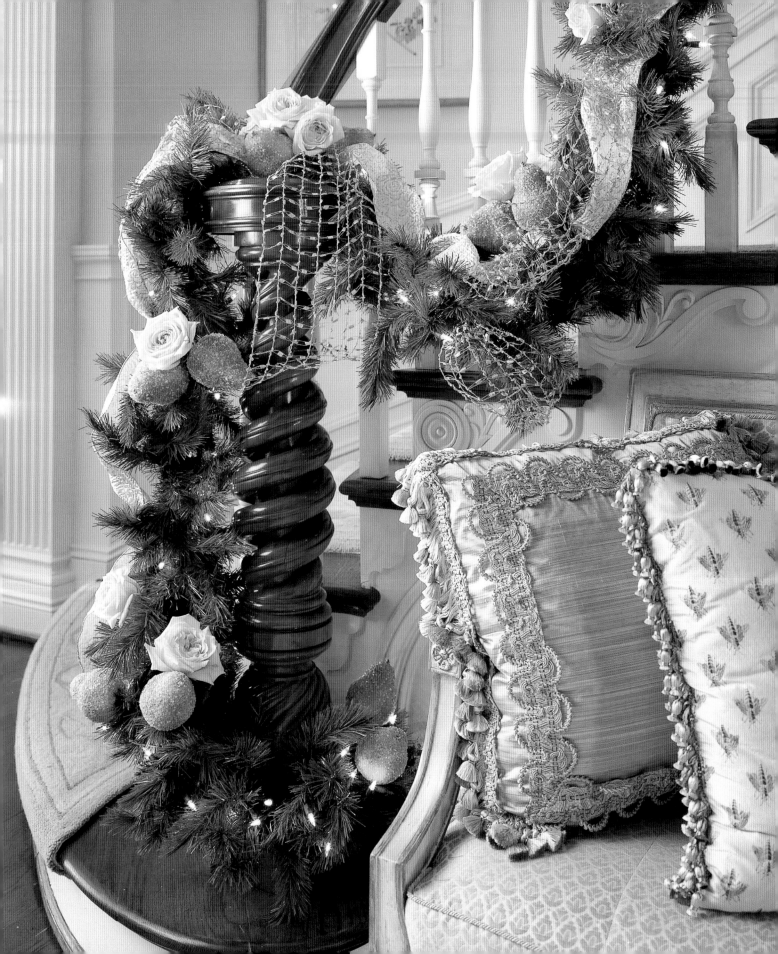

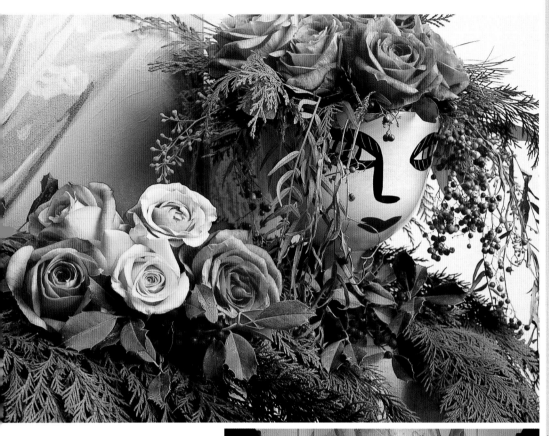

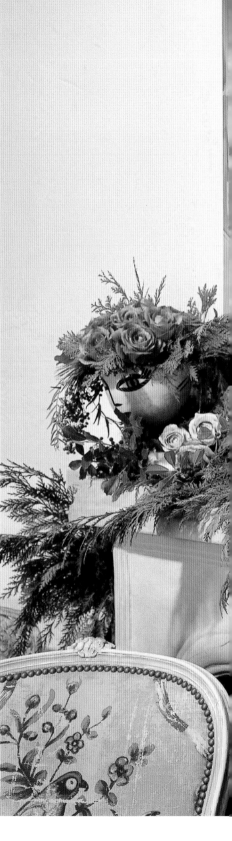

AN EXUBERANT P. S.
Gordon painting in Toni
Garner's living room adds
dramatic emphasis to her
love of flowers. A holiday
garland on the mantel
wears rose bouquets
repeating the hues of the
painting, and at each end
of the mantel, whimsical
rose-filled urns reflect
their owner's good cheer.

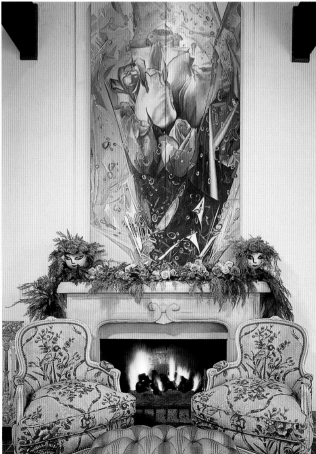

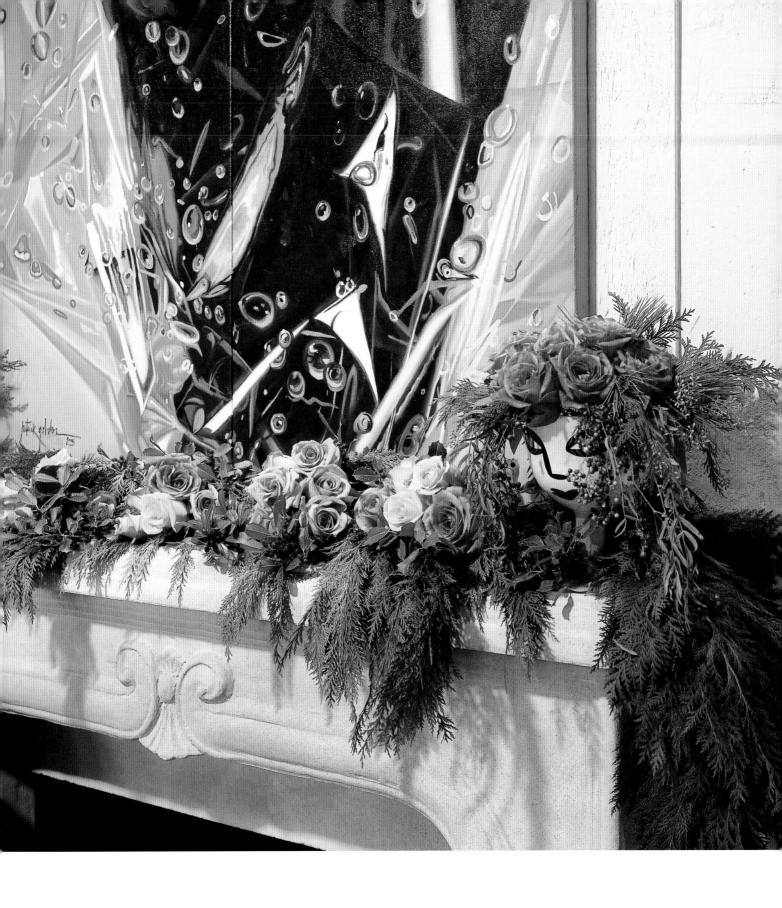

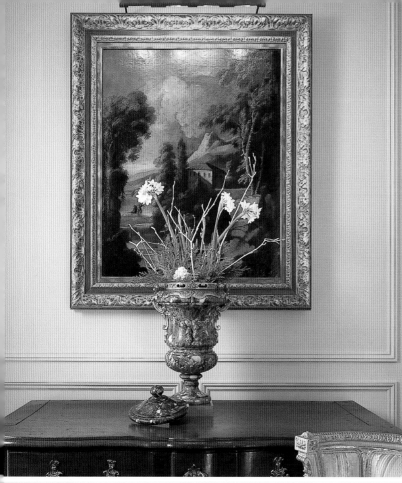

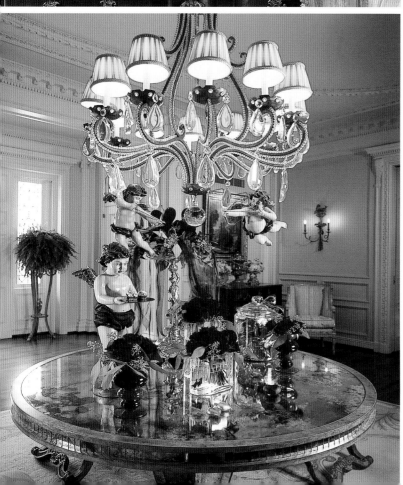

A LOUIS XVI marble and ormolu urn holds paperwhite narcissus beneath a c. 1820 Dutch painting, *above left*. Celebrations start at the front door of the Nickel home. The table in the entrance hall is center stage for Christmas, Valentines, Easter, and Halloween festivities. Here Cupid, et al., add ribbons and red roses in honor of romance, *below left*. Draped in gold and encrusted with ornaments, the Nickels' Christmas tree is an opulent still life, *facing*.

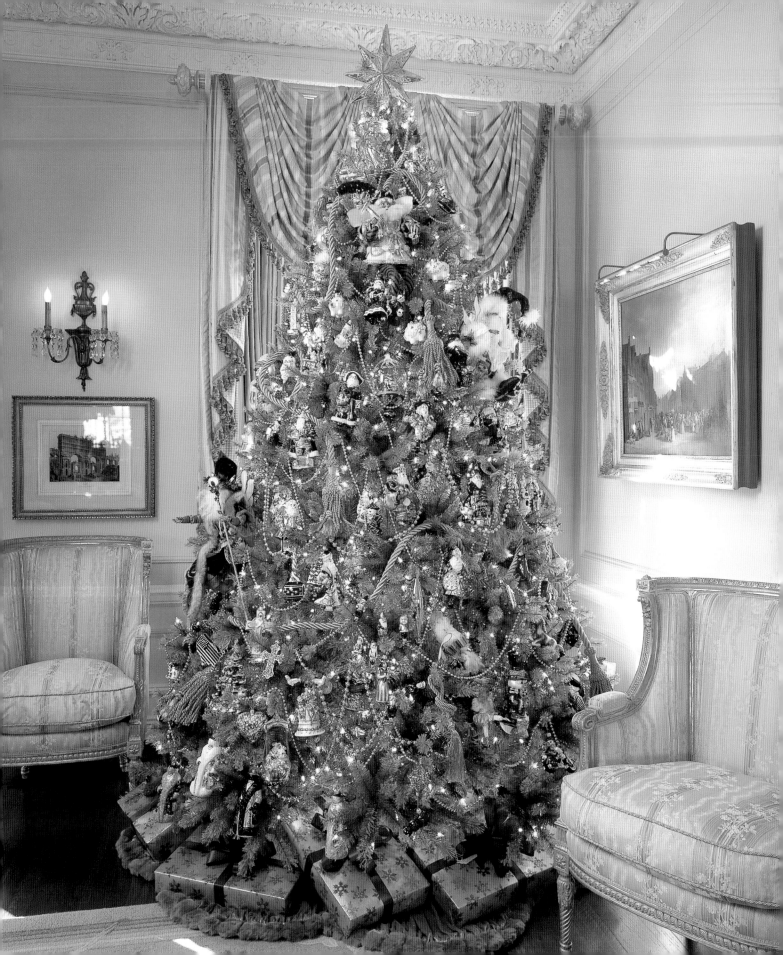

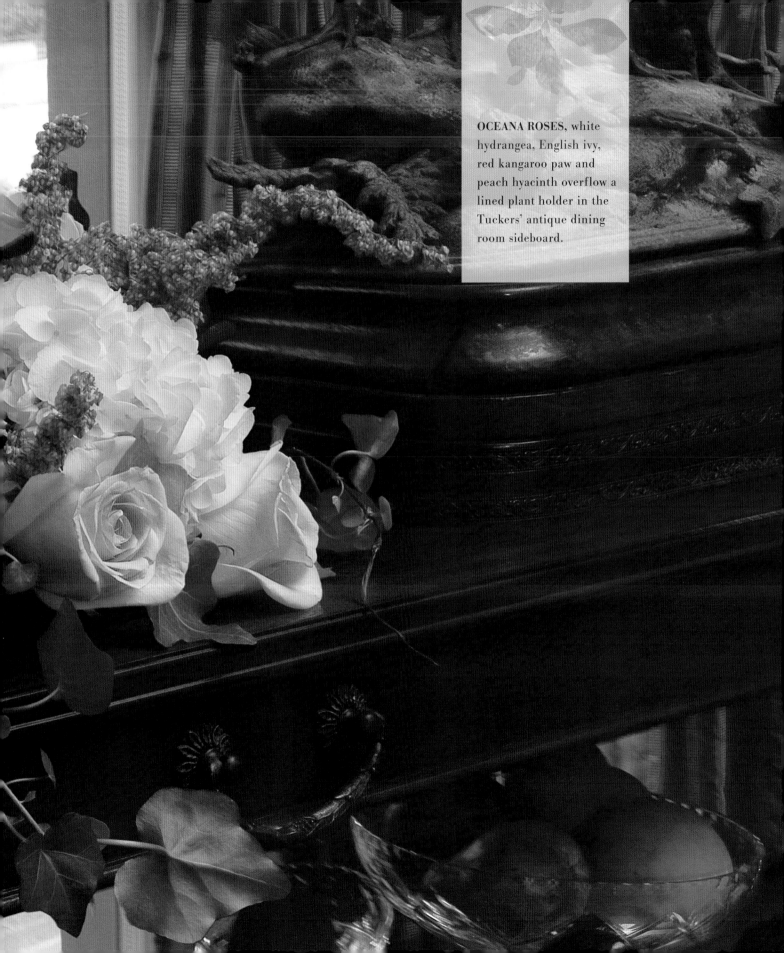

OCEANA ROSES, white hydrangea, English ivy, red kangaroo paw and peach hyacinth overflow a lined plant holder in the Tuckers' antique dining room sideboard.

"THE TEST OF A
HOME IS WHETHER IT MAKES THE
VISITOR FEEL AT EASE."

—Philippa Tristam

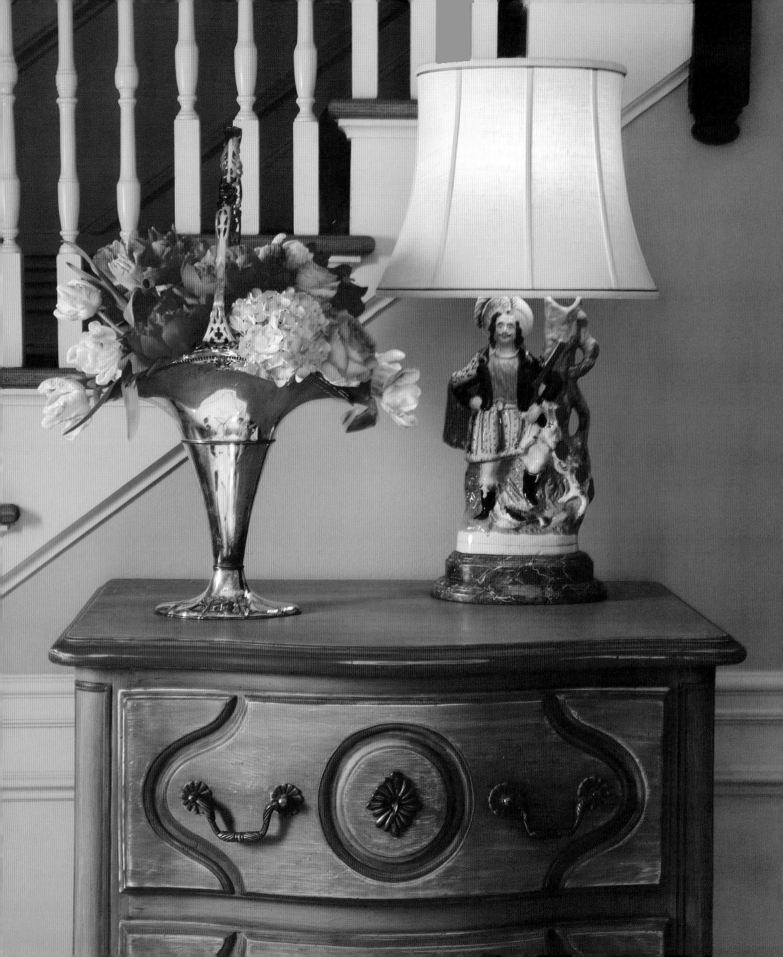

THE FRENCH
commode's finish-
ing touches are a
bouquet of Weber
tulips, coral peonies
and blue hydrangeas
in an antique silver
basket, lit by a cus-
tom Staffordshire
lamp.

MY COLLECTING URGES are very important to the way I live. The rooms where I spend time every day have chairs for sitting, tables for putting things on and lamps for reading. These are all functional items.

But my rooms are also filled with constant reminders of special people, times and trips. I have wonderful heirlooms from relatives, cherished gifts from friends and objects that bring back happy memories of good times and good friends. My belongings are my everyday joys.

I'm a sentimental slob. I just have to have my memories and my memory-jogging things. I don't think this is the same as materialism. Some of the things I love the most I paid nothing at all for. Some were flea market finds. Of course, I have to admit that some were also wildly expensive and had to be purchased over time.

Everyday Joys

In the process of collecting and accumulating, I've tried to temper my enthusiasm with a little restraint. I've been quoted many times as saying, "Too much is never enough." I used to have that design philosophy, but I've been proven wrong over the years by a few who keep adding things to their homes without subtracting.

Too much *can* be too much. I'm still all for abundance in decorating, but I've come to realize it should be abundance under control.

My personal efforts to keep my love of abundance under control have had a happy side effect. My house is filled with gifts in the making. Things that have given me years of pleasure are good candidates for sharing with friends as new memories for their homes.

—Charles

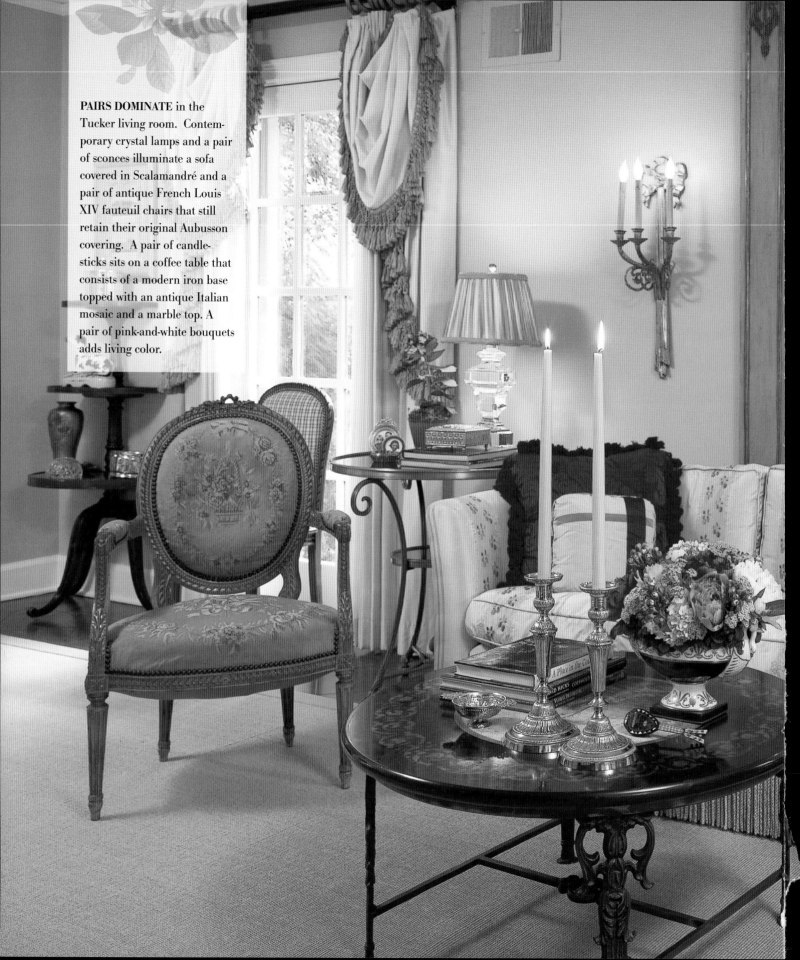

PAIRS DOMINATE in the Tucker living room. Contemporary crystal lamps and a pair of sconces illuminate a sofa covered in Scalamandré and a pair of antique French Louis XIV fauteuil chairs that still retain their original Aubusson covering. A pair of candlesticks sits on a coffee table that consists of a modern iron base topped with an antique Italian mosaic and a marble top. A pair of pink-and-white bouquets adds living color.

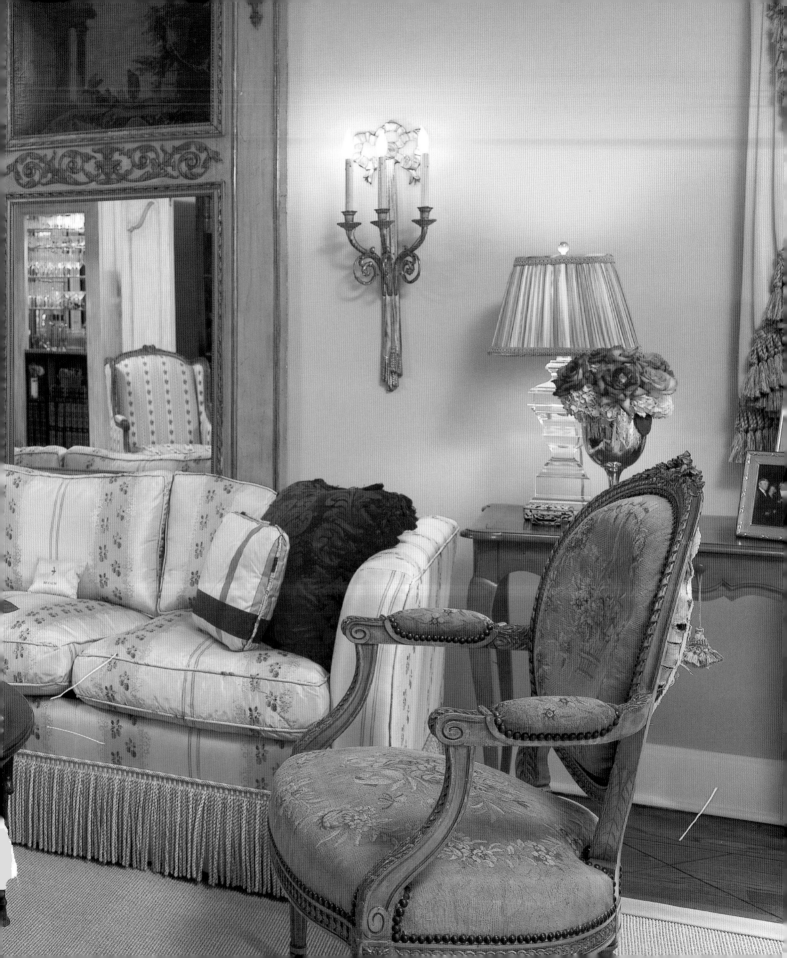

Bouvardia, yarrow
and peonies, *right*. Slick Willy, in
the Tucker Home,
prefers the Scalamandré silk for his
afternoon nap.

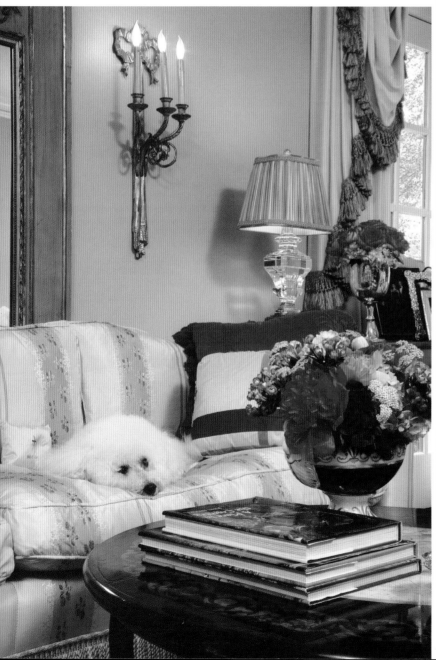

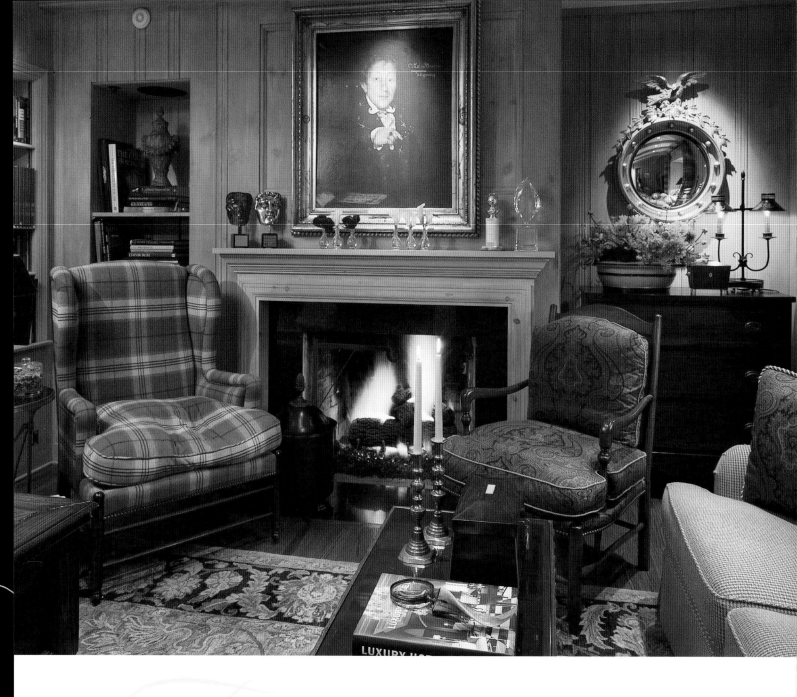

THE KNOTTY pine–paneled library in Jennifer and Mark Radcliffe's home is a tranquil retreat that includes paisleys and plaids, a Federal period bull's-eye mirror and an antique English chest. It is a book-lined sanctuary, but one that is, on closer inspection, equal parts fact and fantasy.

The sorcery at work here comes from Mark, a movie producer whose credits include the legendary Harry Potter films. His portrait above the mantel is labeled *Vric the Oddball, Supreme Mugwump*. It was a gift from the art department on the film *Harry Potter and the Prisoner of Azkaban* and was used in the movie. Accessories on the mantel are awards for that film and for *Mrs. Doubtfire*.

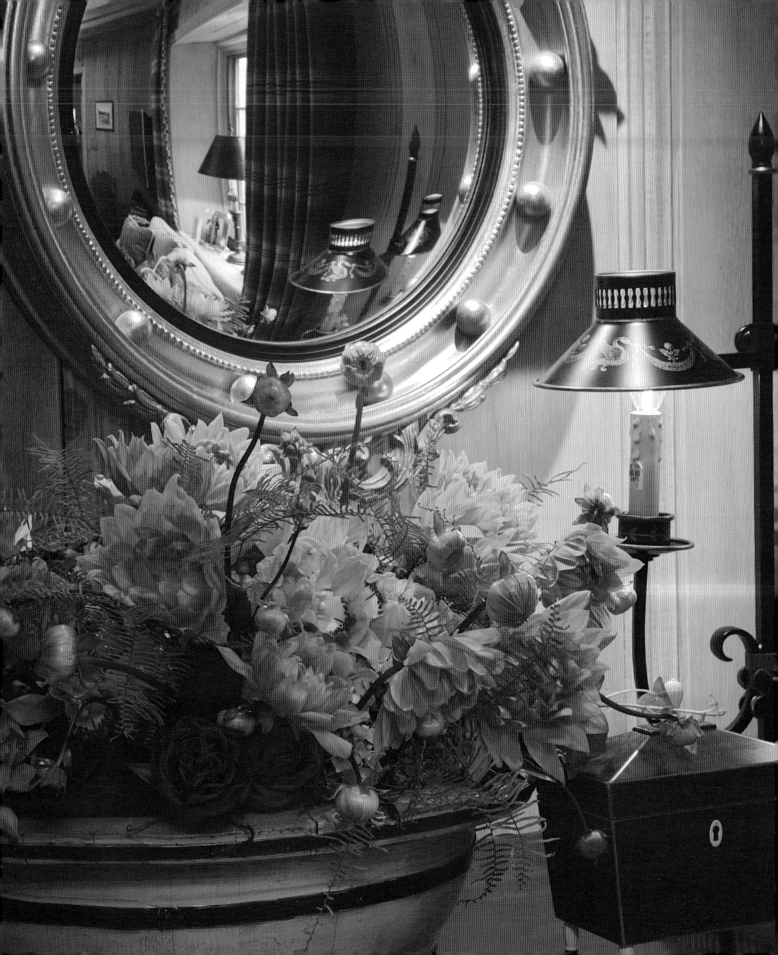

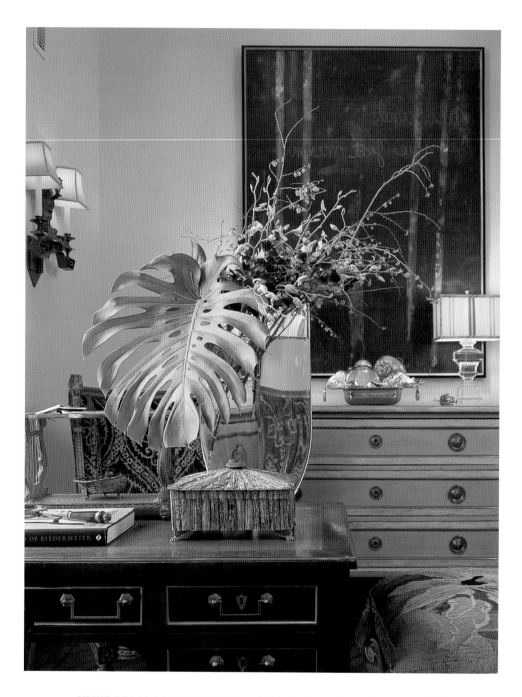

USING PURPLE DENDROBIUM orchids, elm branches and monster leaf,
Toni created an architectural arrangement with the weight and boldness to complement a
large contemporary vase. In the background, a painting, *Saigon Gates*, was
a gift to Francie Faudree and Dale Gillman from the artist, Joe Niermann, *above*. Duralee
fabrics are used for draperies and a pair of "Sophie" Country French
chairs from Charles Faudree Collections. *facing*.

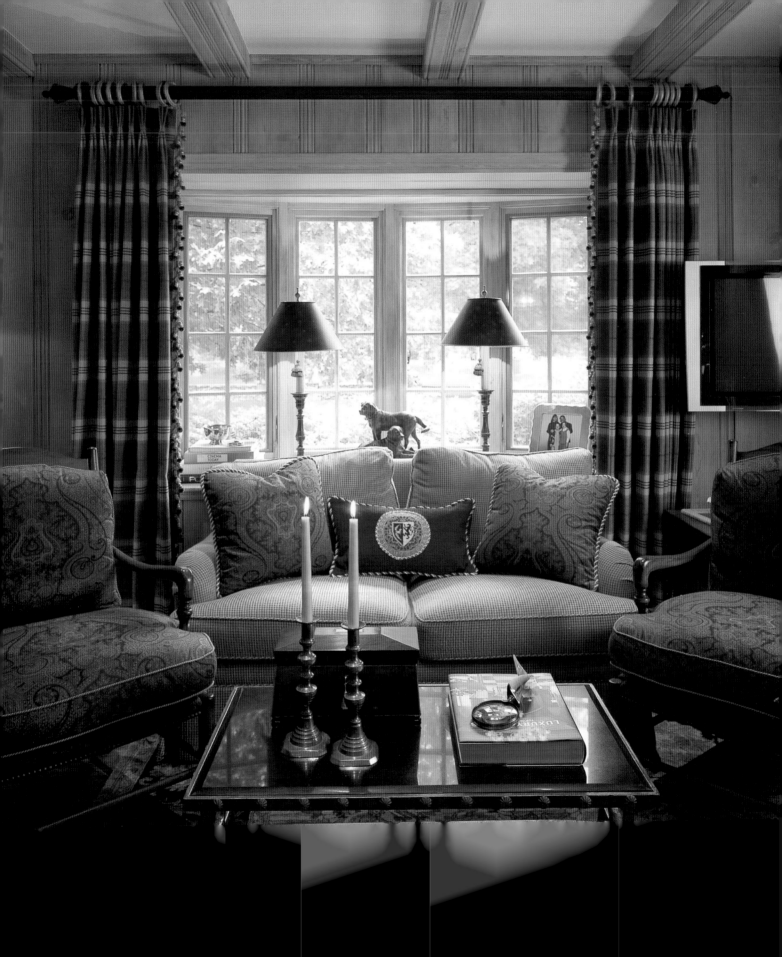

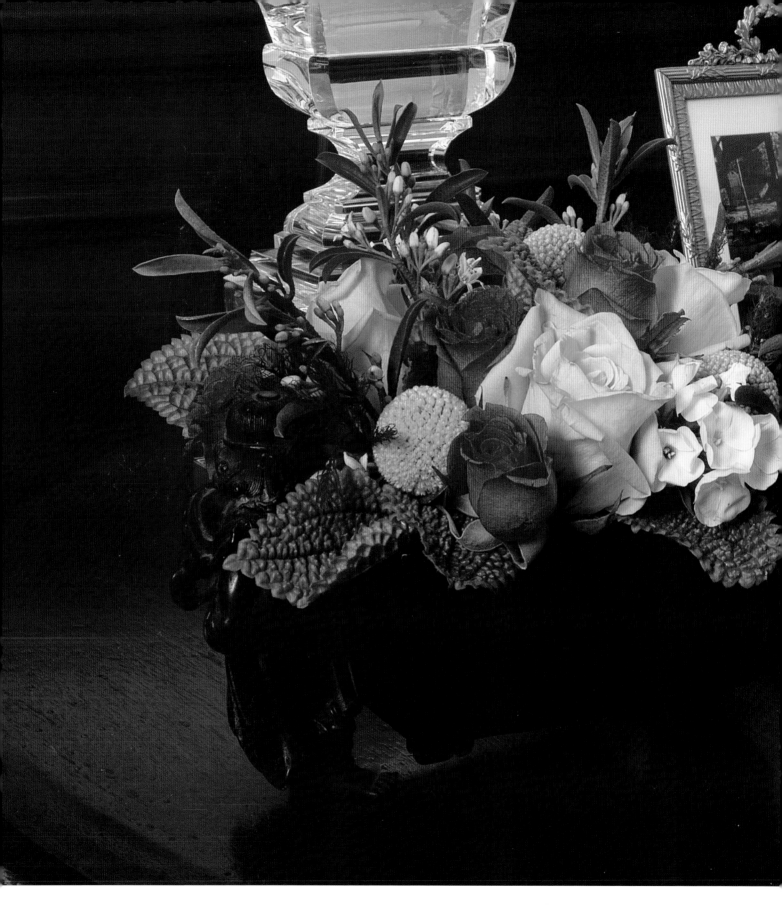

A COLORFUL NOSEGAY of roses, phlox and
caspedia (dilly flower) benefits from its bronze box, *facing*.
A wall grouping in Earlene Foster's library
showcases an antique Victorian barometer flanked by tole
bouquets. Bergère chair covered in "Zambezi" print
by Brunschwig and Fils, *below*.

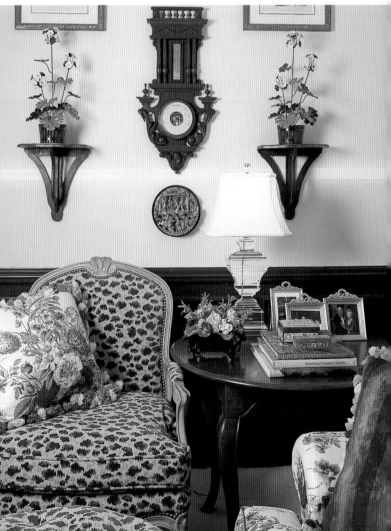

A FRESH FLOWER spray on the banquette is ready to take to a favorite party host, *above*. A Louis XIV country French armoire, club chairs and contemporary glass table create an easy mix. The variety is emphasized in the floral arrangement, a striking composition of traditional hydrangea and pussy willow in a modern glass container, *facing*.

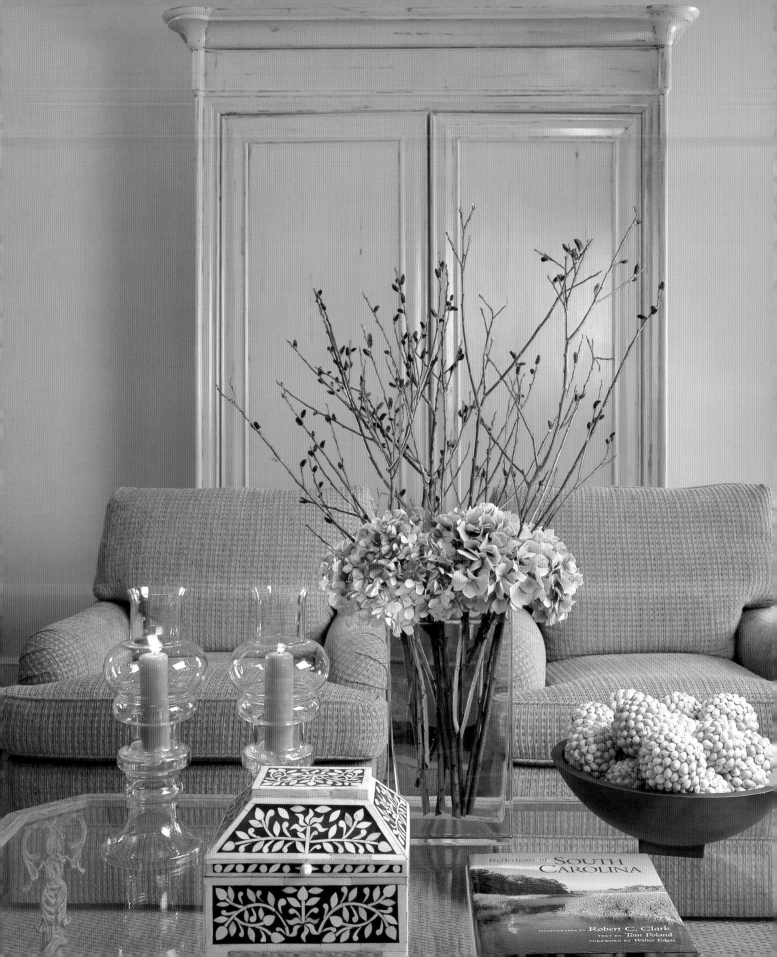

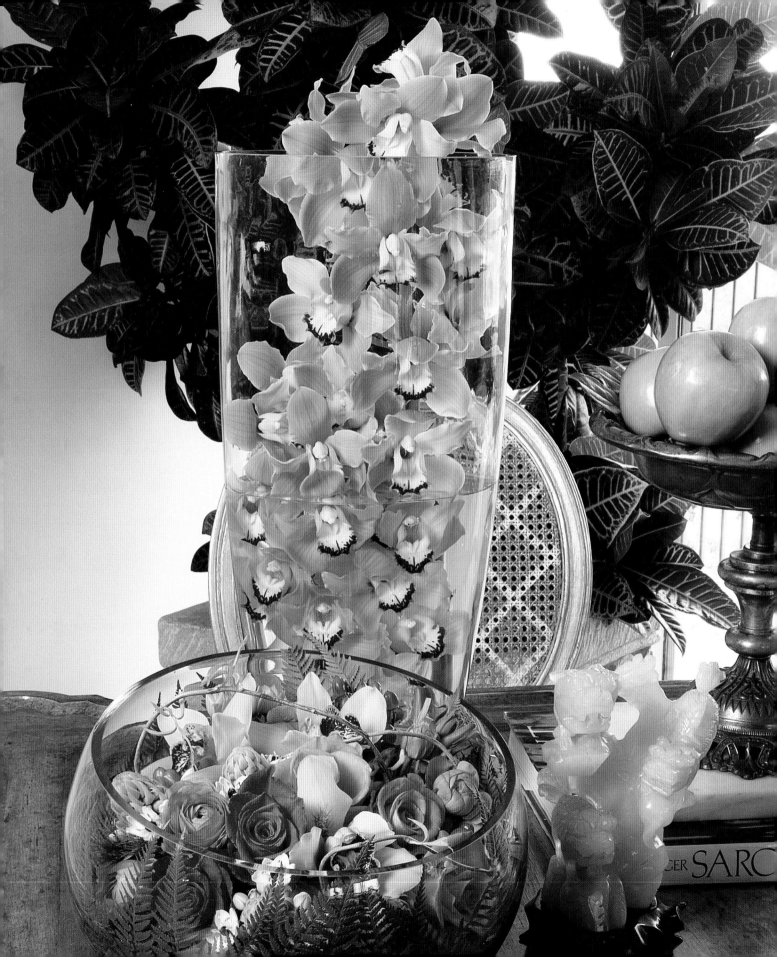

Bouquets for Everyday Living

Even though I entertain in the kitchen, I also spend a lot of happy private moments cooking. I always keep a floral arrangement there for my own pleasure. Actually, the bouquets are often vegetables, because in my kitchen, cabbage is king.

Transforming vegetables and fruits into decorative arrangements is a simple solution to a common kitchen quandary: where to put all that produce? Instead of trying to cram groceries into cabinets or the refrigerator (which can diminish their flavor), I like to put them on display.

Glass bowls or cylinders filled with fruit make wonderful arrangements. I include lemons or limes or both. Apples are beautiful, and pears are too, of course. My arrangements reflect what is in season and what I'm going to be cooking. Kale is a wonderful garnish for fruit or flowers. For a dose of pure color, I combine eggplant and tomatoes in a large glass bowl.

In winter, I sometimes add pinecones, cinnamon sticks and pomegranates to my vegetable "arrangements." In summer, I buy little bundles of fresh flowers from the farmers market to brighten my produce displays. My friends were surprised to see me buying flowers at all, since I own a flower shop. My excuse was that I was trying to help the local economy; but in truth, the bouquets were so pretty that I couldn't resist.

In every season of the year, I keep small pitchers filled with fresh herbs on the kitchen countertop. Their scent is delightful. Their flavors can transform a busy-day meal. Most of all, the miniature arrangements of basil, rosemary, chives and thyme are the perfect final garnish for my private moments.

—Toni

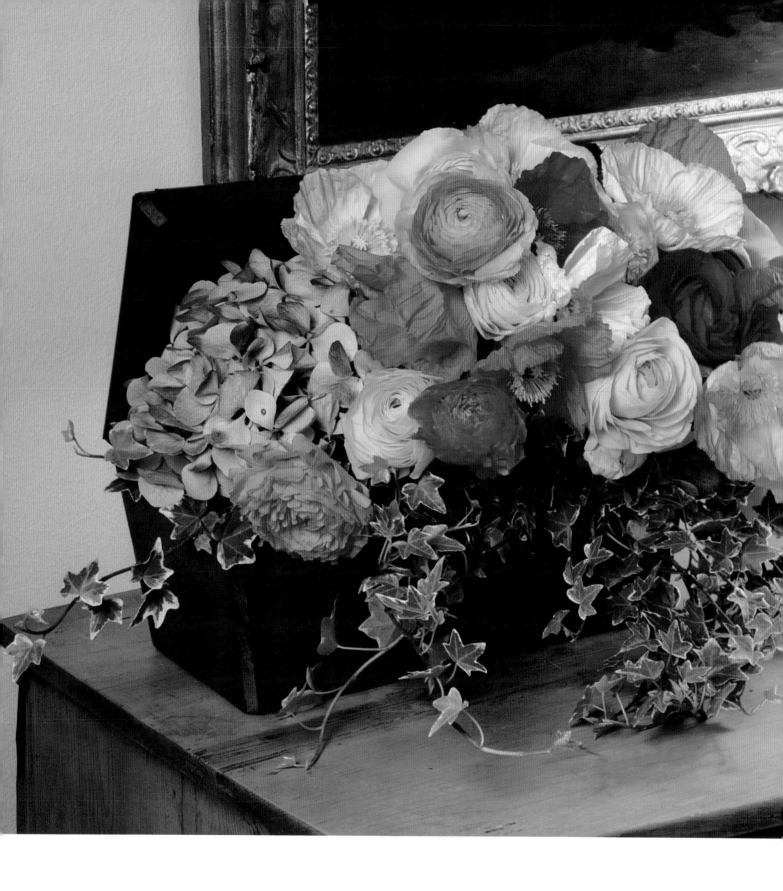

A **COLLECTION** of English antiques on
an antique English pine chest greets visitors in the Simpson
entry hall. The custom tole lamp was originally
a tea tin, and a recycled English tea box now serves up a
bright bouquet of ranunculus, hydrangea and
poppies on a bed of ivy.

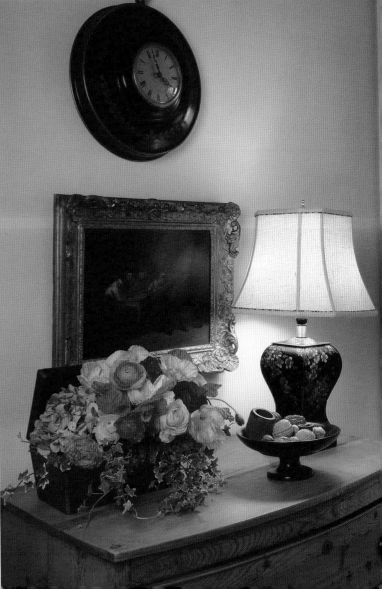

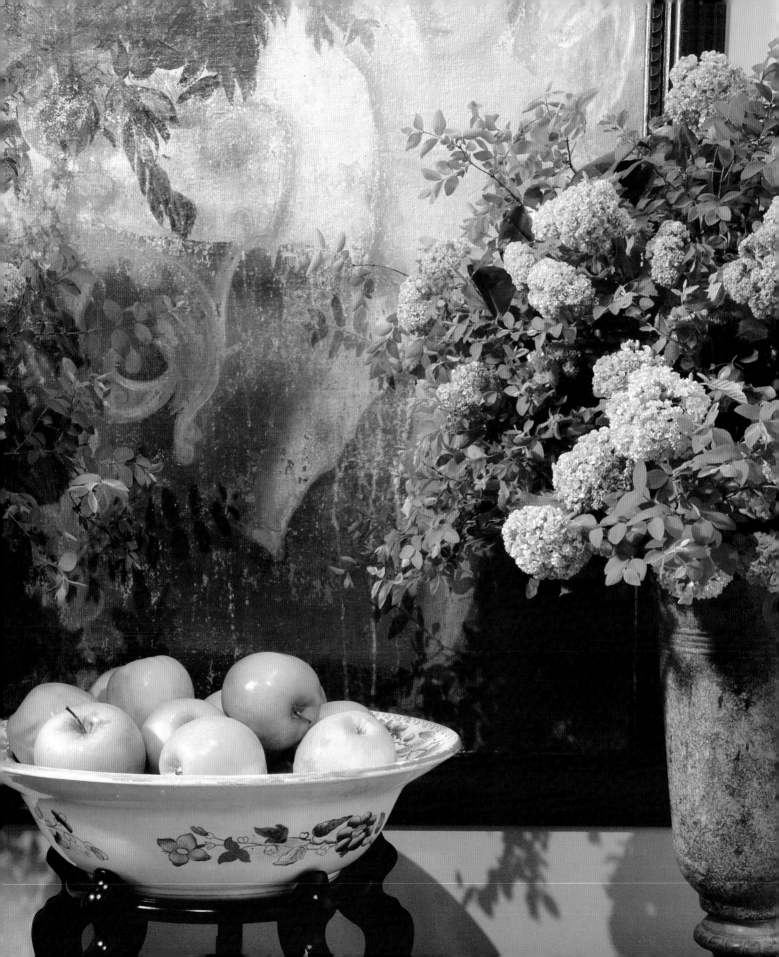

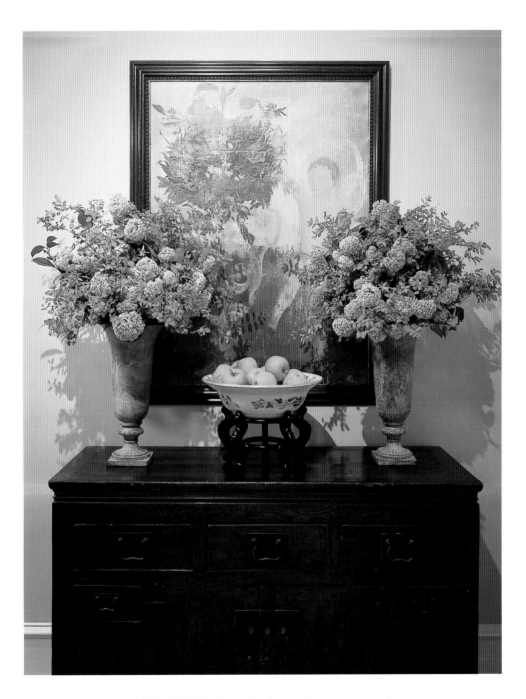

A VERDANT SETTING in the Hughes great room is
created by an eighteenth-century-style Italian painting and tole urns filled with
Toni's evocative green viburnum bouquets. A bowl of green apples on
the antique Chinese chest completes this wonderful composition.

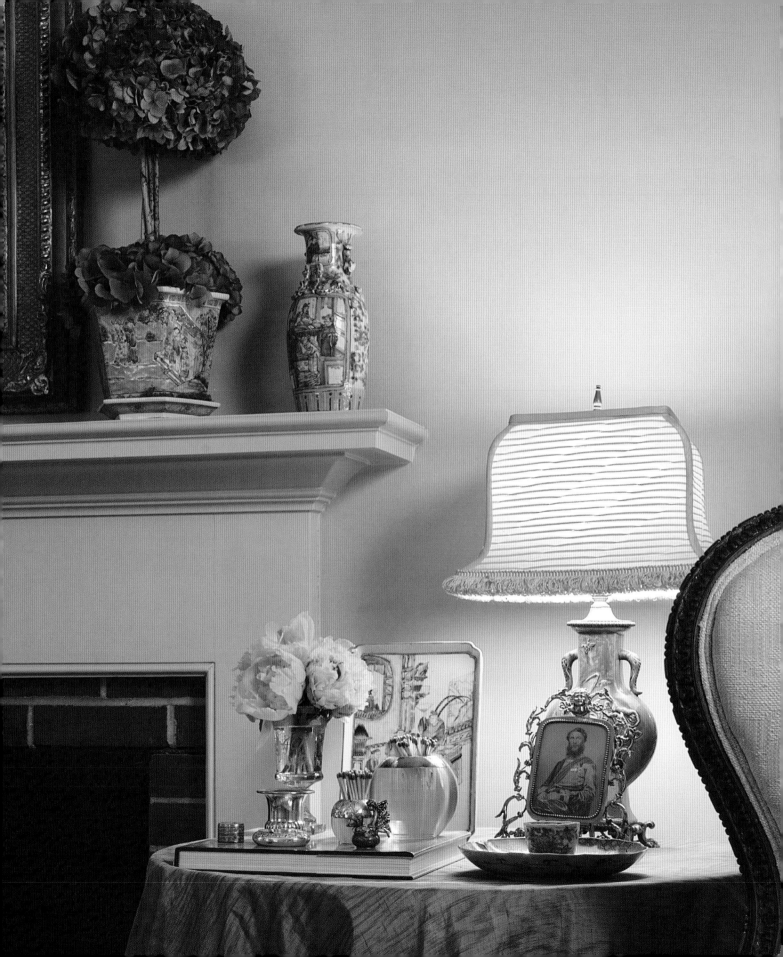

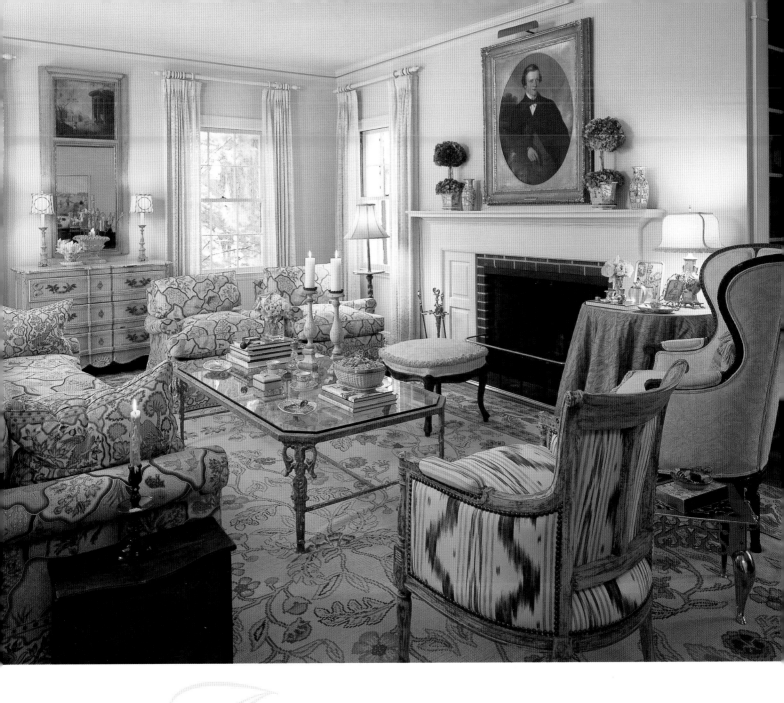

AN ARRESTING custom
lamp and shade highlight a
table in the Franden living
room, *facing*. A portrait of
Thomas Russell Crampton
by J. Sydney Willis Hodges

overlooks the Frandens'
living room. The colors of
the sofa and club chairs,
covered in Brunschwig and
Fils, and a fauteuil chair,
covered in Pierre Frey, are
complemented by a custom

rug by Edward Fields. A
Niermann Weeks French
garden coffee table is acces-
sorized with antique Italian
altar sticks, an English
game dish, and majolica,
above.

Charles Faudree's *Country French*

ANIE SIBUET

A FRENCH COUN
STYLE AND ENTER

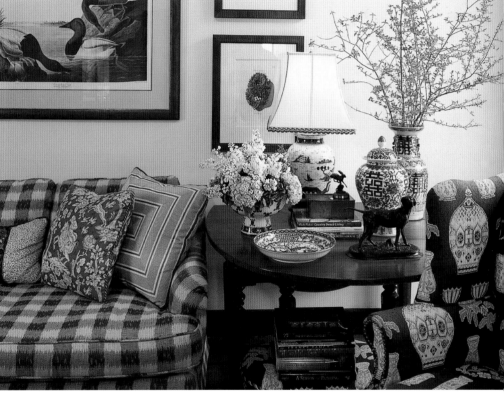

A SIMPLE ARRANGEMENT OF
branches from the garden has an Oriental feel in harmony with
its blue-and-white Chinese export vase, part of a
collection in the Lockard den. Sofa and chair covered in
Brunschwig and Fils continue the color theme.

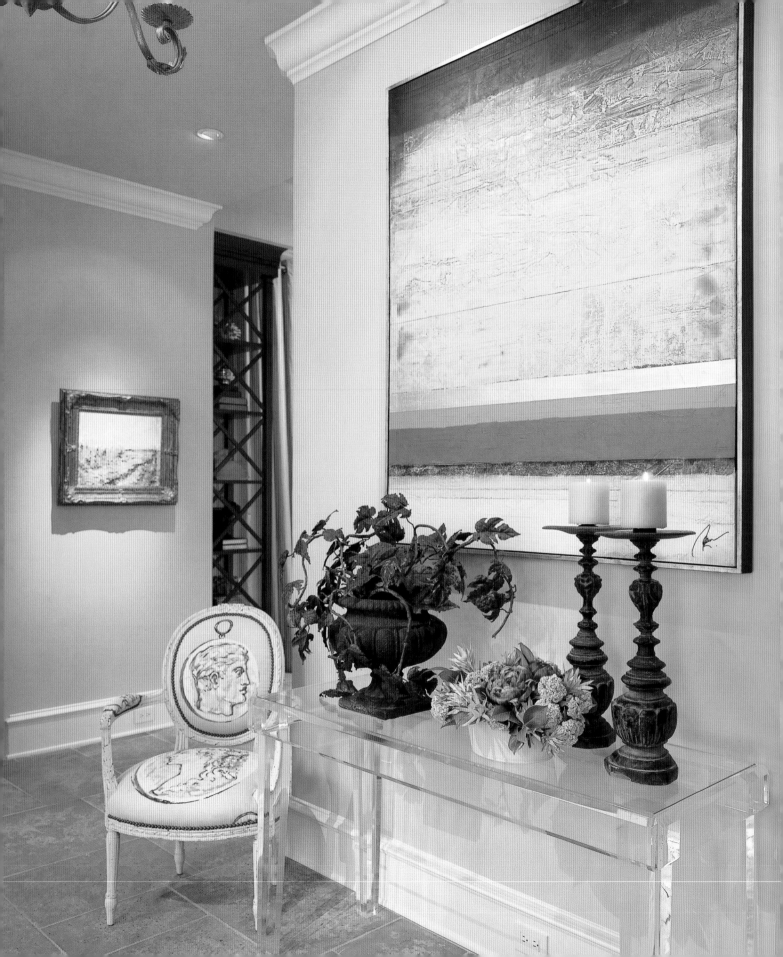

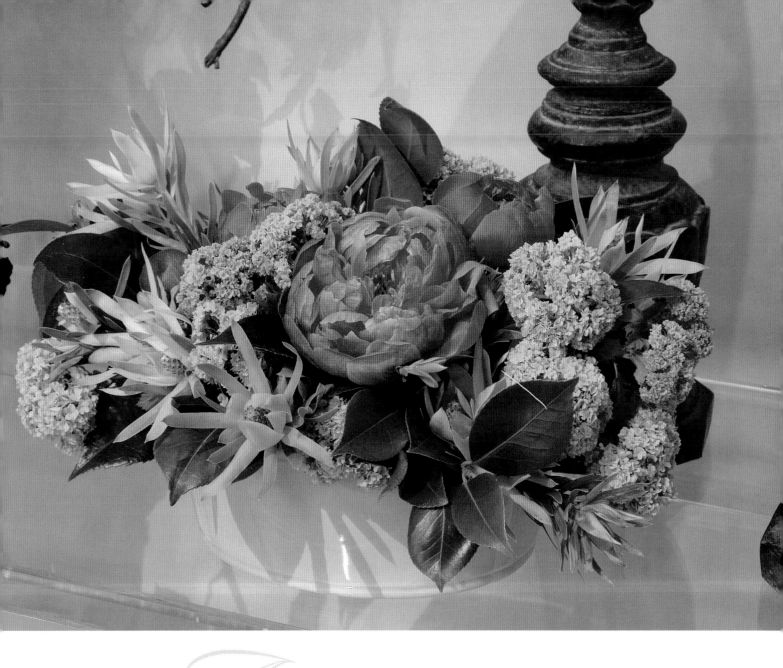

A LUCITE ENTRY CONSOLE, a contemporary painting and an antique French fauteuil chair covered in Pierre Frey fabric form an urbane introduction at the home of Tom and Sally Hughes. Accessories include antique Italian altar sticks and a nineteenth-century garden urn filled with a copper leaf bouquet. *left*. Bright peonies are the center of attention in this lovely bouquet, *above*.

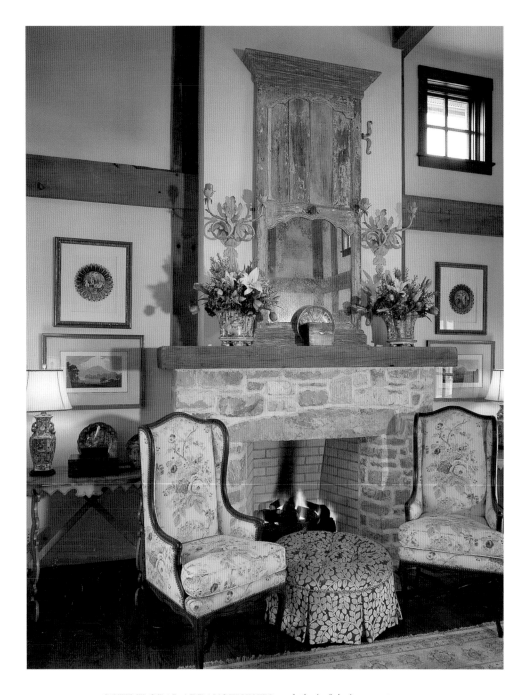

SOFT FLORAL ARRANGEMENTS and their fabric counterparts
contribute to the warmth in the Lockard living room, *above*. Kale and artichokes
in a vegetable container become a striking culinary
accessory with the addition of creamy roses and viburnum, *facing*.

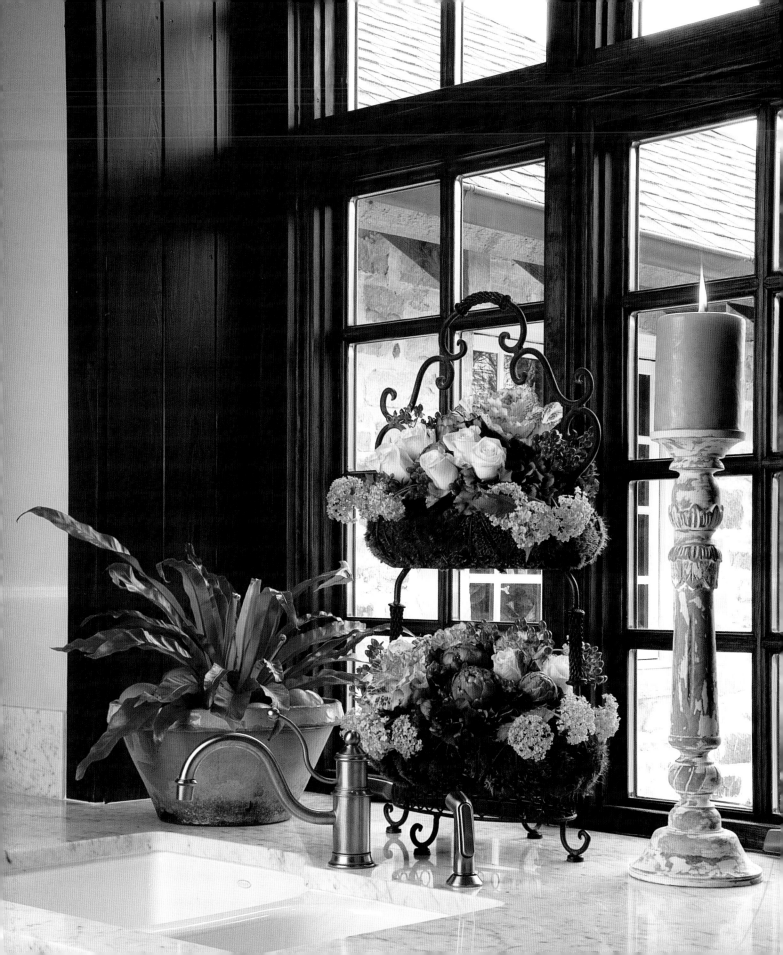

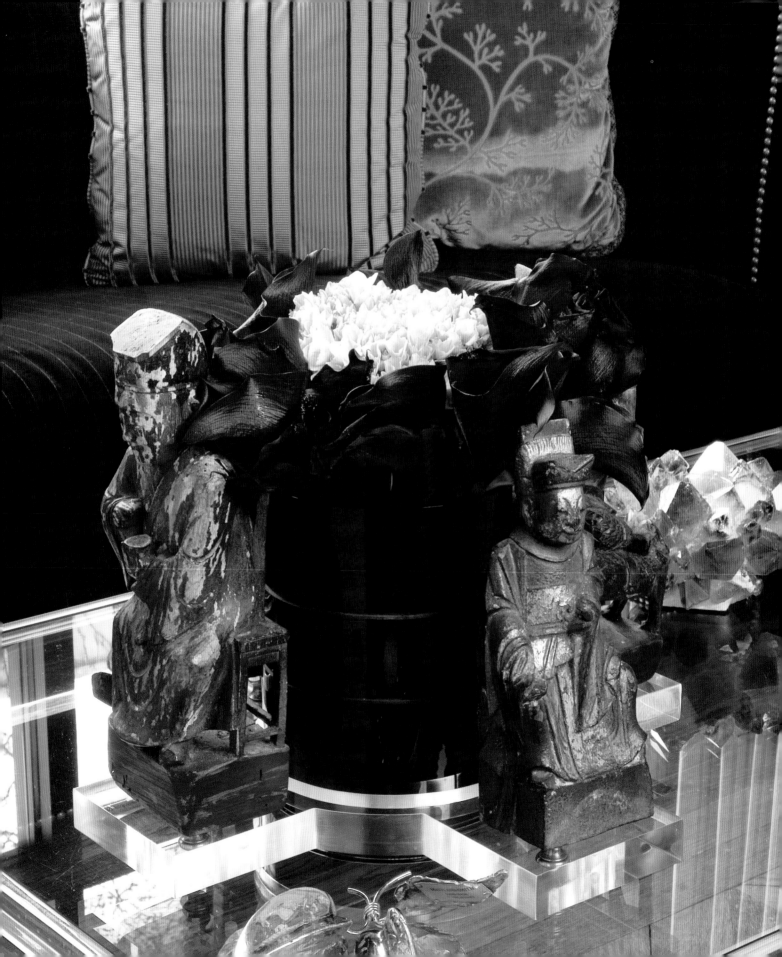

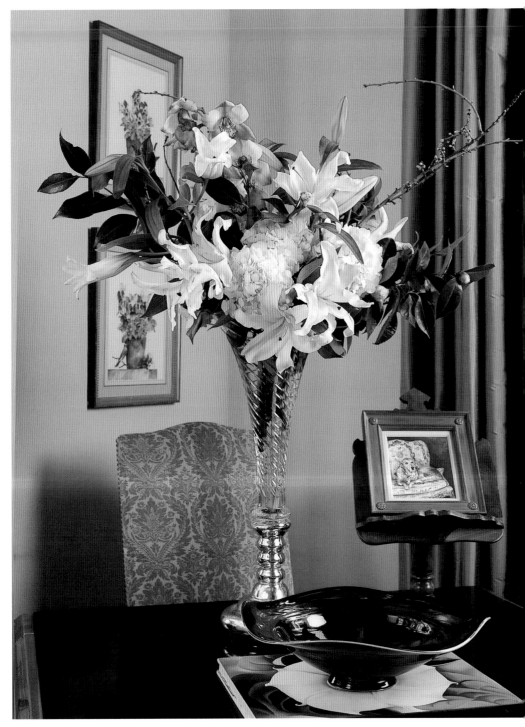

A SLEEK ARRANGEMENT of black calla lilies and green hydrangea in black glass are flanked by Qing Dynasty figures, evoking the mysteries of the Orient, *facing*. An antique silver vase highlights an arrangement of white lilies and hydrangea, spiked with pink cymbidium to accent the color of a modern bowl. French chairs team with a Lucite game table. The antique bookstand holds a painting of 'Purdy' Pielsticker by artist Jimmy Steinmeyer, *right*.

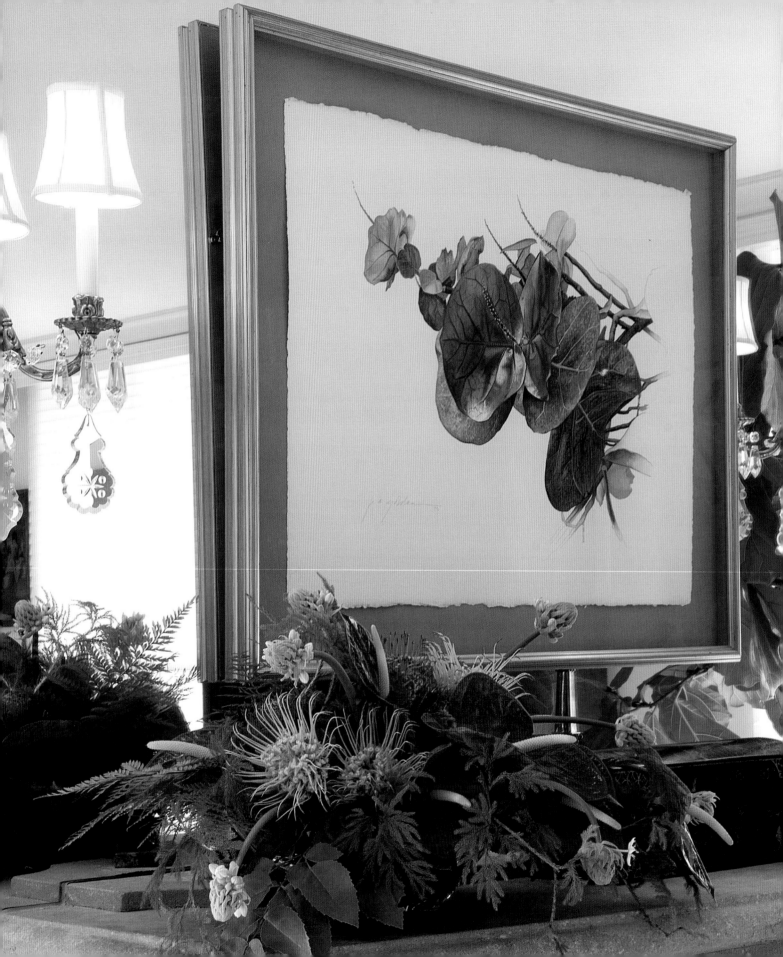

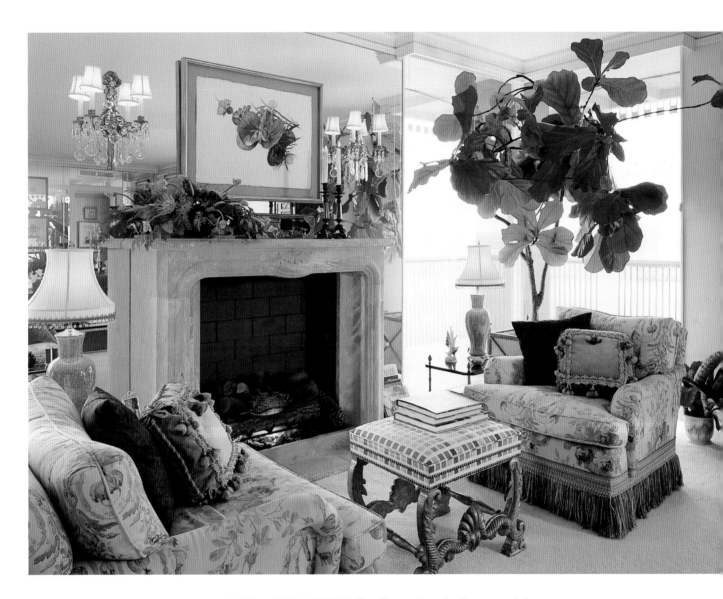

P. S. GORDON'S PAINTING *Sea Grapes* is perfectly accented, but not
obscured, by a low tropical arrangement containing anthurium, protea, ornithogalum and
Australian greenery, *facing*. Dramatic accessories evoking the flavor of
the tropics are showcased against subtle colors in Earlene Foster's living room. Club chairs
are covered in "Aubusson Rose" by Travers. French stool is by Minton Spidell. *above*.

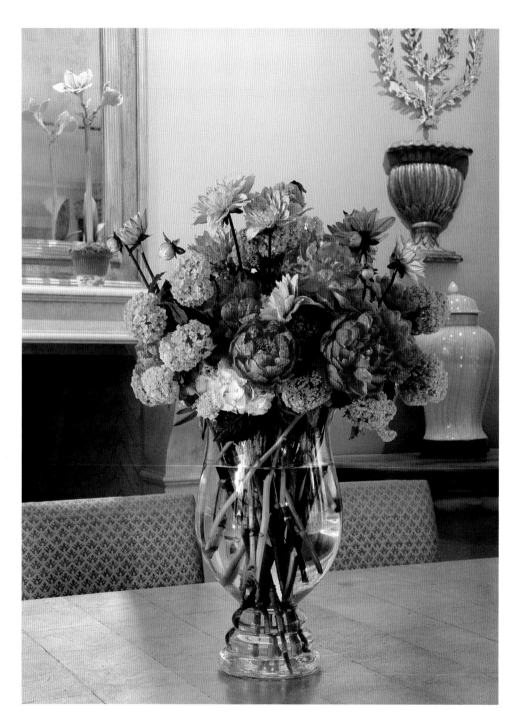

LACED STEMS of peonies, viburnum and dahlias in a clear gloss container contribute to the impact of this bouquet, *above*. A French mirror reflects an antique ormolu clock and a dramatic floral arrangement atop a faux tortoiseshell commode by Brunschwig and Fils, *facing*.

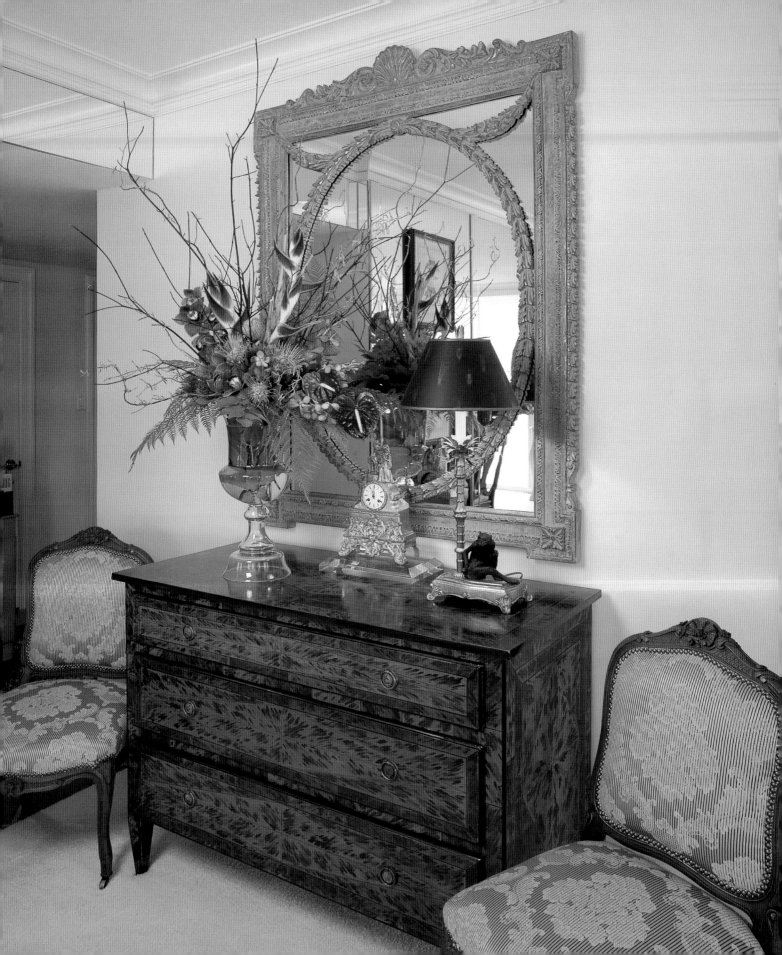

THE INCLUSION of contemporary glass vases of parrot tulips adds a pleasant dash of surprise to a traditional arrangement in an antique wooden tray. The paired composition of contemporary and antique has both warmth and "edge" that complements the antique English painting above, *below*. Lamps and moss pot arrangements flanking a birdcage on the Country French buffet are an example of how to pare down with pairs, *right*.

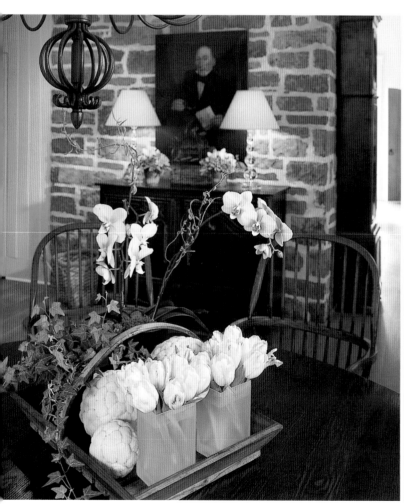

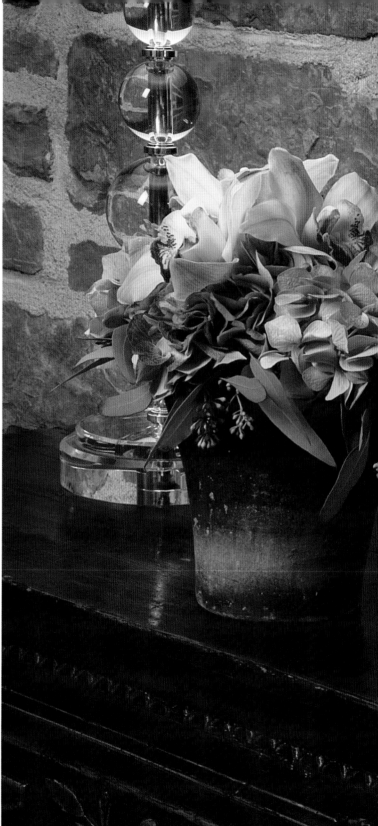

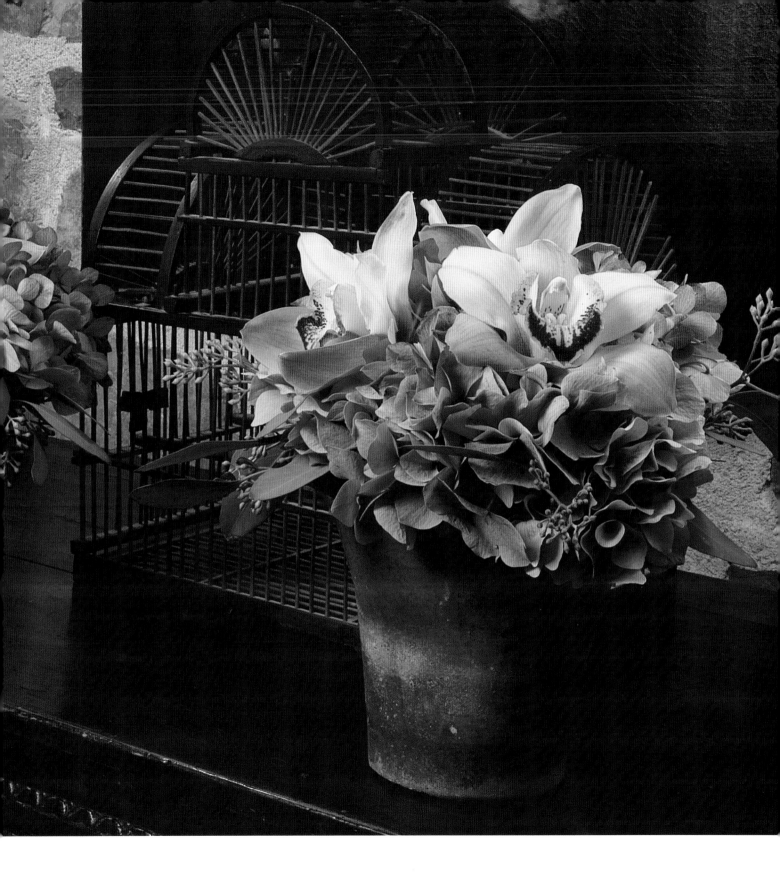

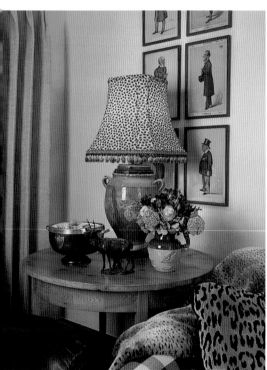

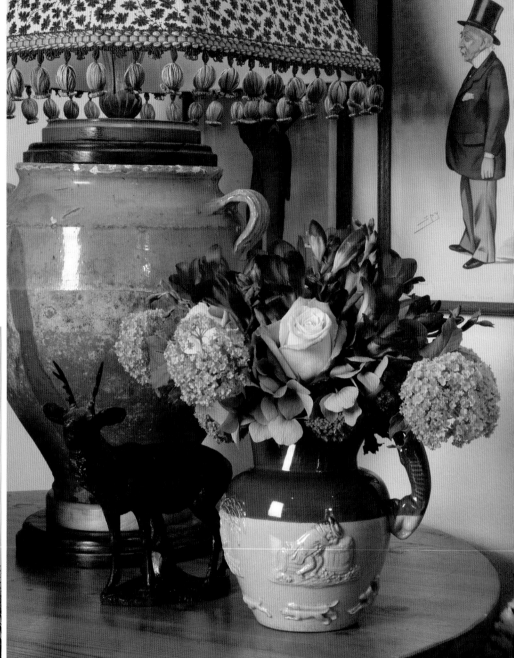

A PINE TABLE, checks and faux furs create a warm mood in the Simpson library. Accessories include an English wood salad bowl serving as a nut dish and a Black Forest carved deer. In the background, a collection of antique spy prints, *left*. A floral arrangement in a salt-glazed jug contributes to the library's cozy feeling, *above right*.

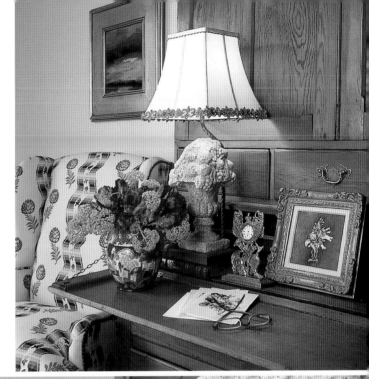

IN THE SIMPSON living room, a nineteenth-century English pine secretary holds a custom stone bouquet lamp. Toni supplies its living counterpart—an arrangement of red parrot tulips and viburnum. Other accessories include an antique French watch holder and a Jimmy Steinmeyer shell painting, *right*. Red parrot tulips repeat the color of their charming container, a Mason's pitcher, *below*.

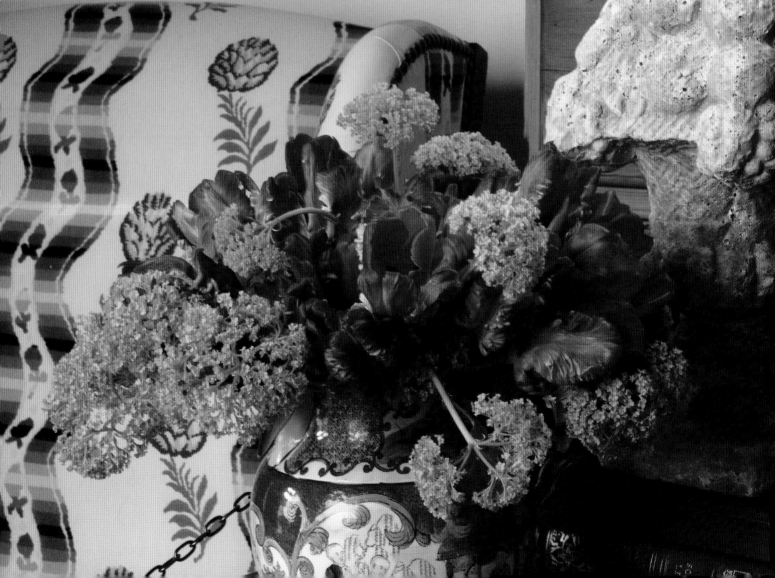

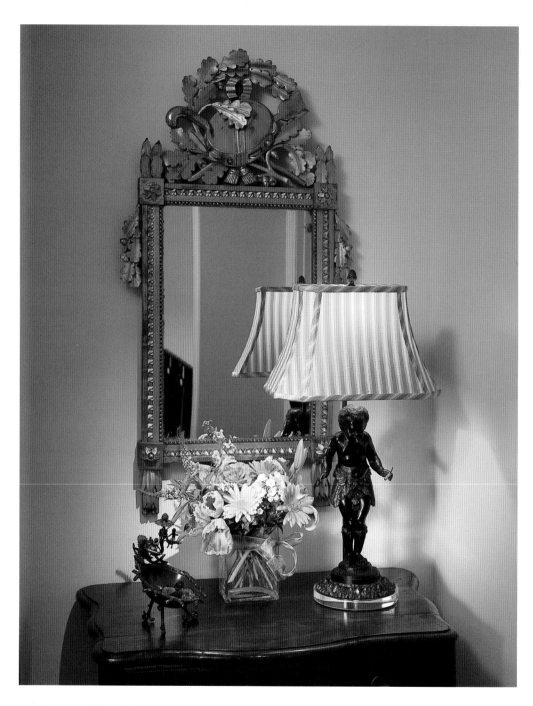

A NINETEENTH-CENTURY BLACKAMOOR is a pastel burner made into a custom lamp.
The mirror, a Louis XVI piece, hangs over a Louis XV console from Provence, *above*. A handsome
mirror and lamp and interesting accessories create a pleasing
composition on a chest. The addition of fresh flowers adds life and color, *facing*.

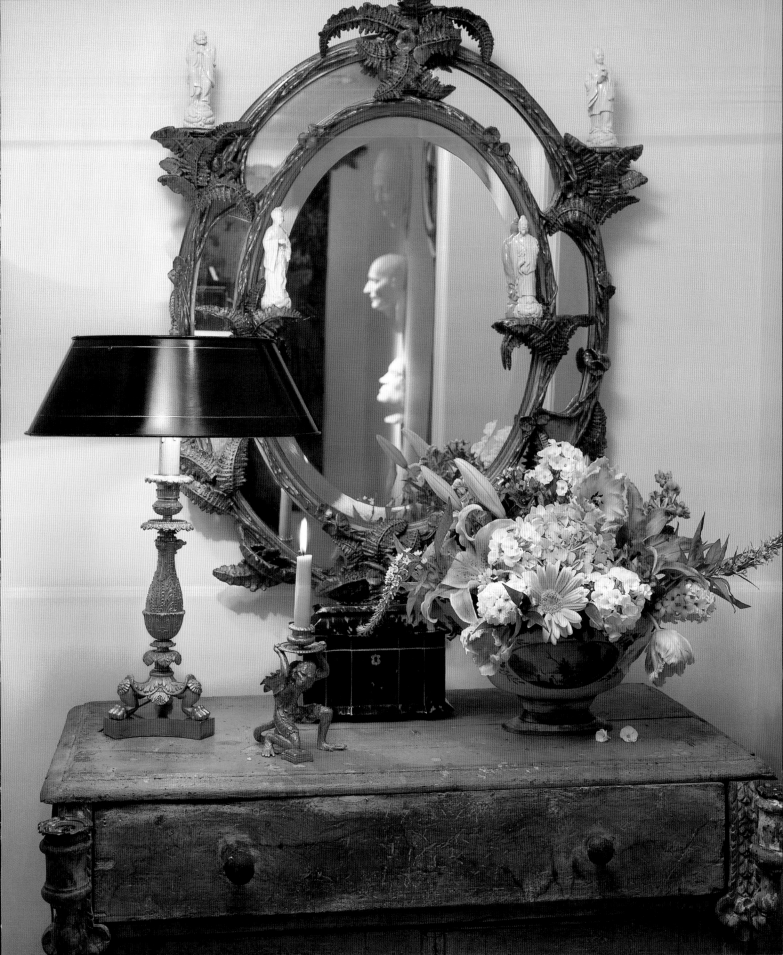

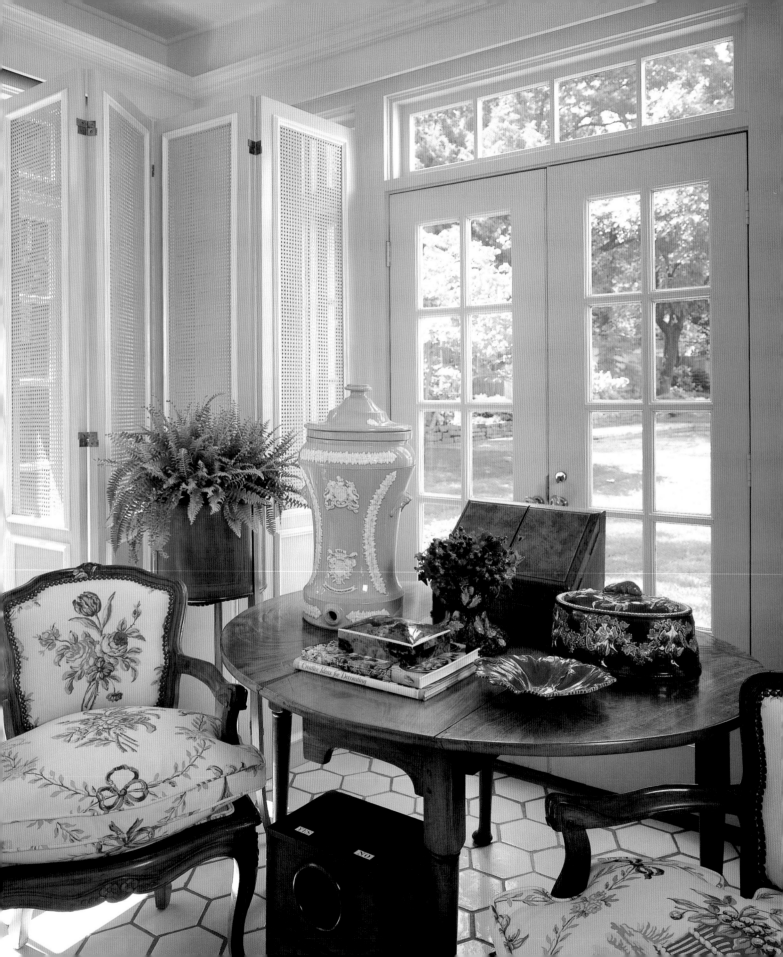

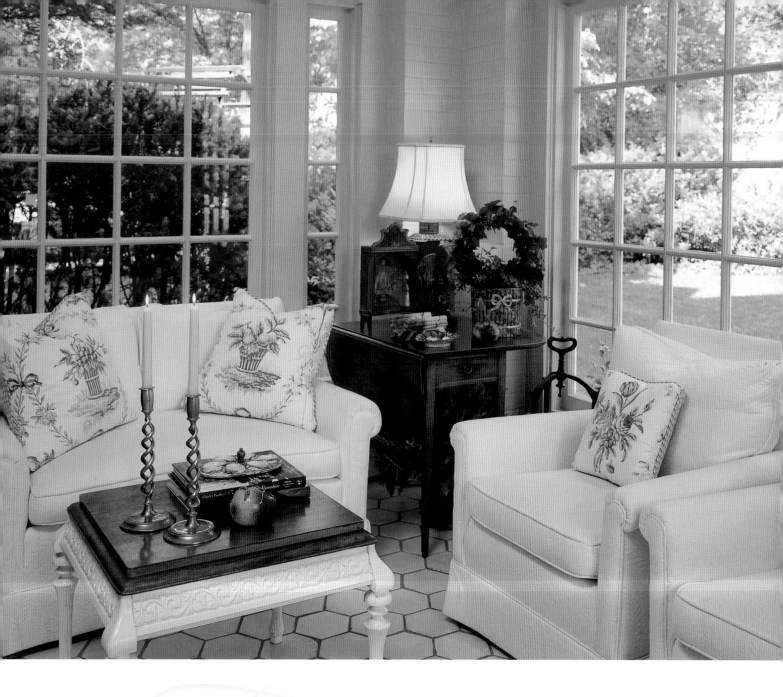

FRENCH AND English influences vie for attention in the Franden sunroom, but the antique ballot box beneath the table is strictly nonpartisan. Tabletop accessories include an antique English water filter, writing desk, majolica game dish and majolica ham stand filled with hypericum berries and ivy. French fauteuil chairs are covered in Brunschwig & Fils. *facing*. Plenty of white creates a serene corner in the Franden sunroom. Majolica and an antique santo in its own case add finishing touches. *above*.

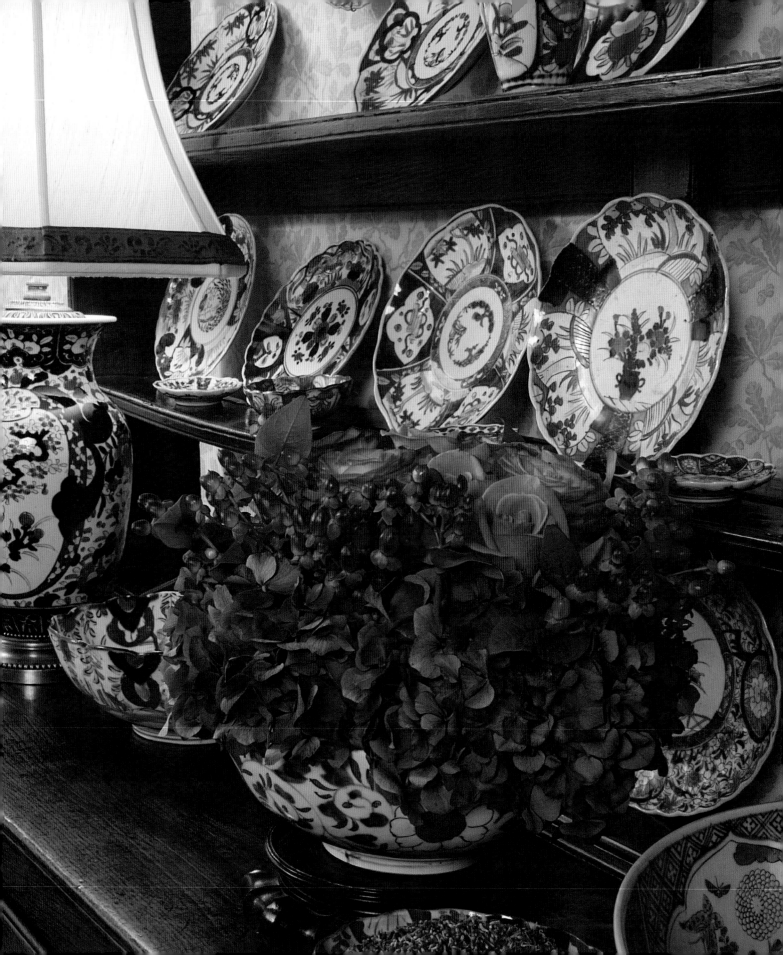

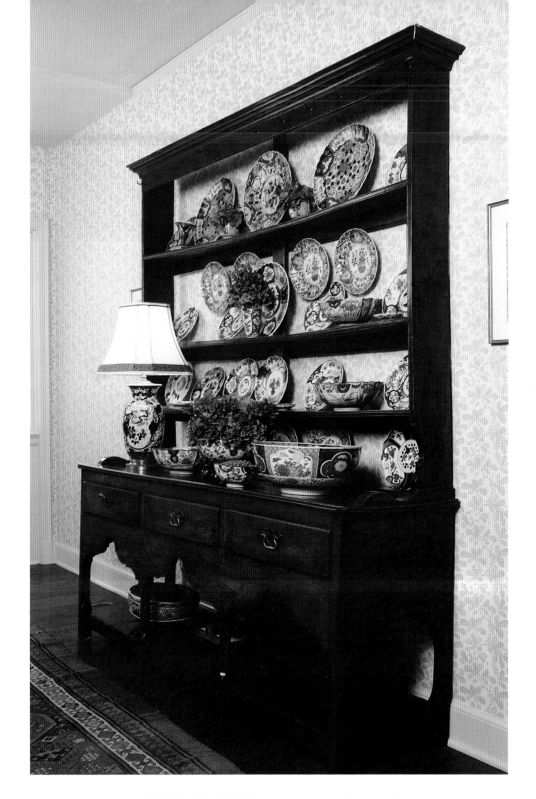

HYPERICUM BERRIES, orange 'Hector' roses and
blue hydrangea highlight an Imari bowl, *facing*. Part of an extensive collection
of Imari overflows an eighteenth-century Welsh dresser in the Franden entry.

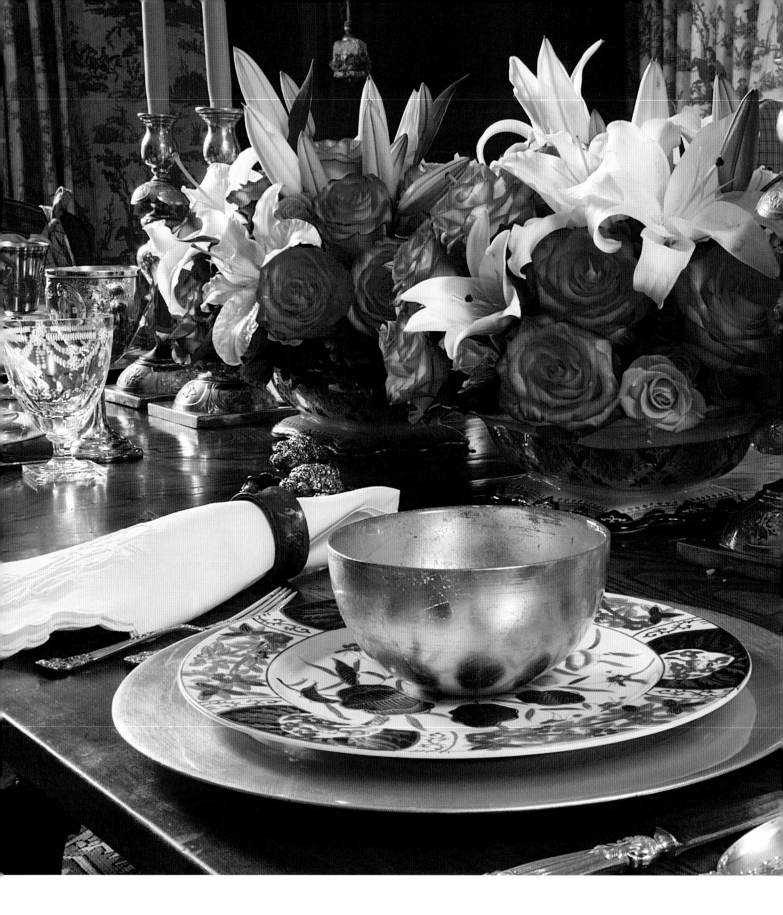

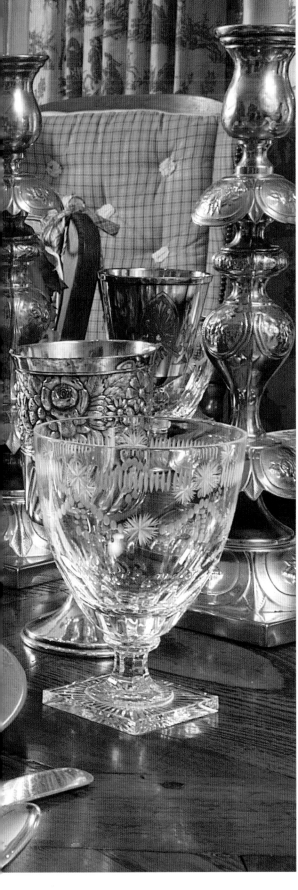

THE ELEGANCE of Gina and Bob Franden's dinner parties is not achieved at the expense of hospitality. Toile wall covering and drapes create a warm setting for French and English country antiques, including a dining table with an iron base and antique French fruitwood top, Imari china and Gena's collection of antique silver goblets. Country French armchairs are covered in a Brunschwig & Fils check, *facing*. Conversation-friendly low centerpieces fill tureens that are part of the Frandens' Mason ware collection.

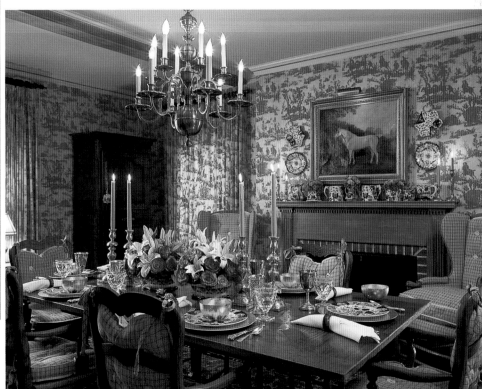

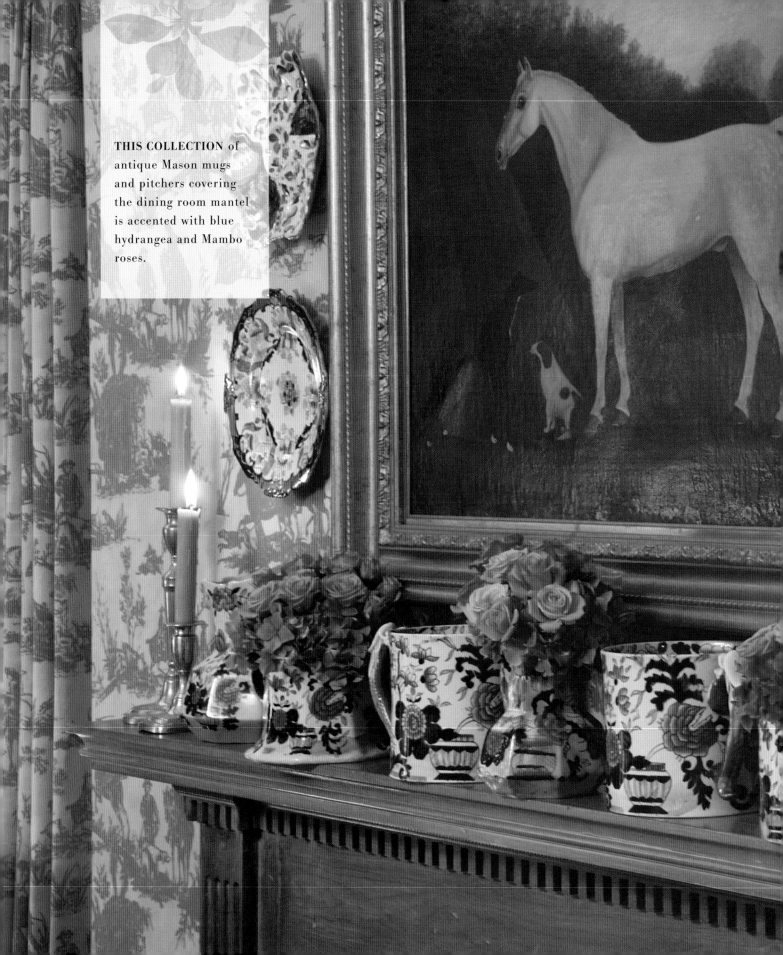

THIS COLLECTION of antique Mason mugs and pitchers covering the dining room mantel is accented with blue hydrangea and Mambo roses.

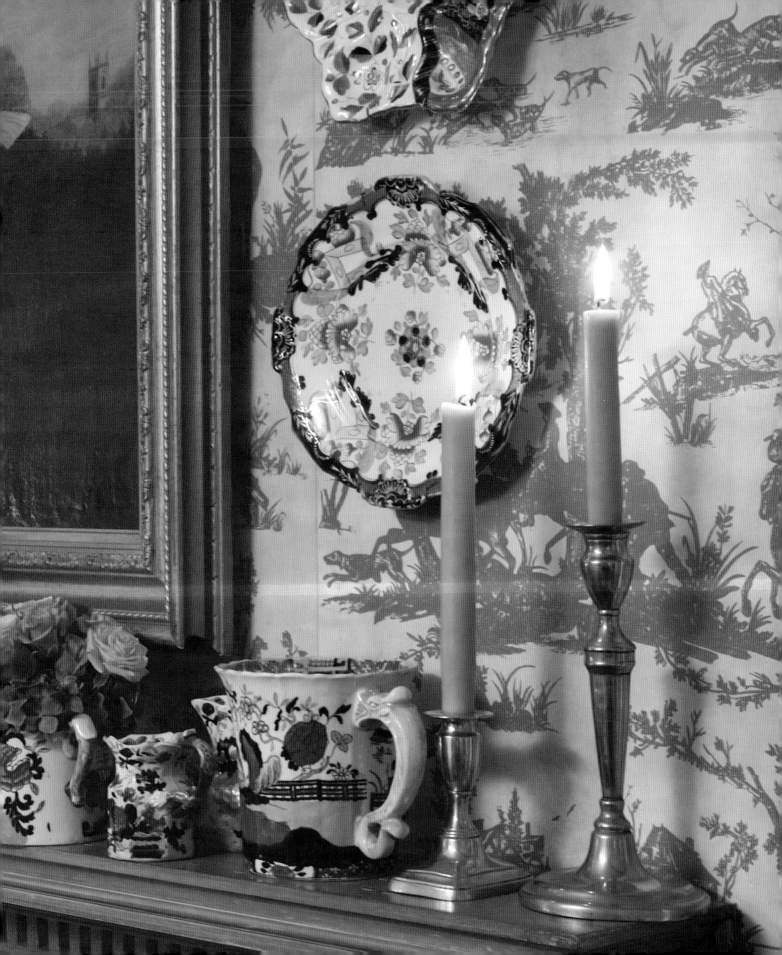

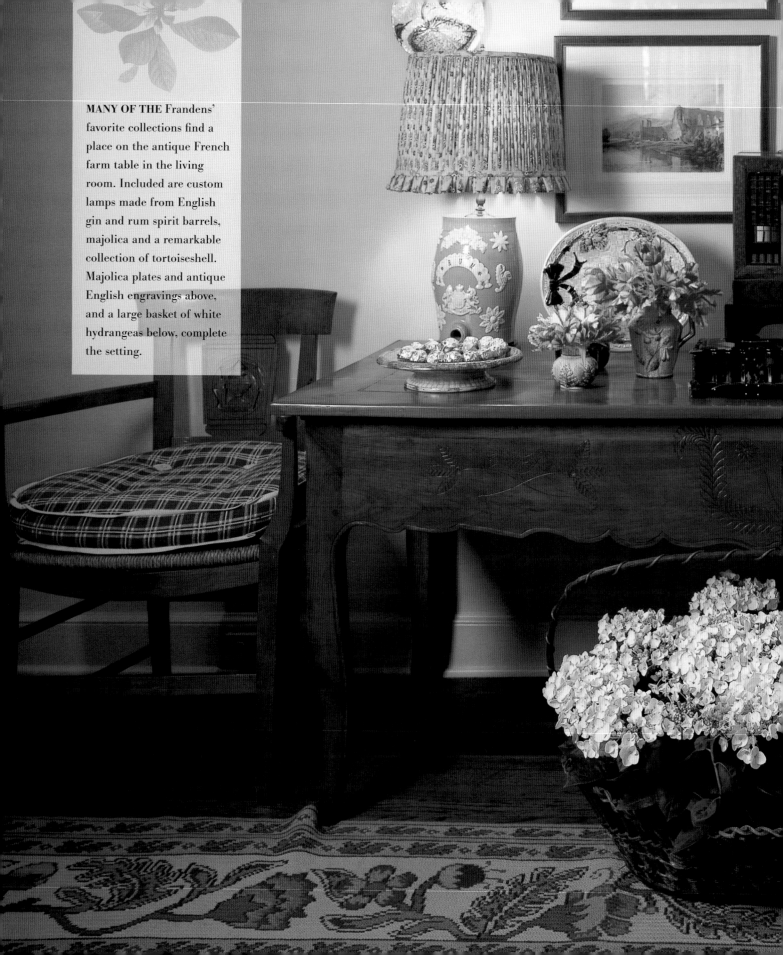

MANY OF THE Frandens' favorite collections find a place on the antique French farm table in the living room. Included are custom lamps made from English gin and rum spirit barrels, majolica and a remarkable collection of tortoiseshell. Majolica plates and antique English engravings above, and a large basket of white hydrangeas below, complete the setting.

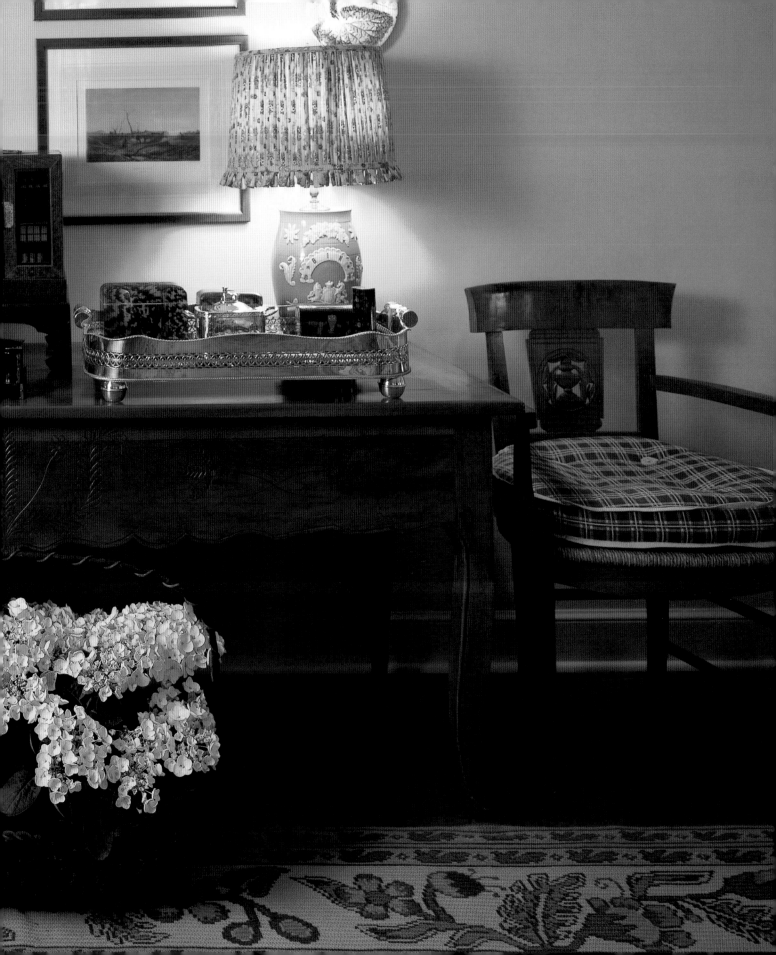

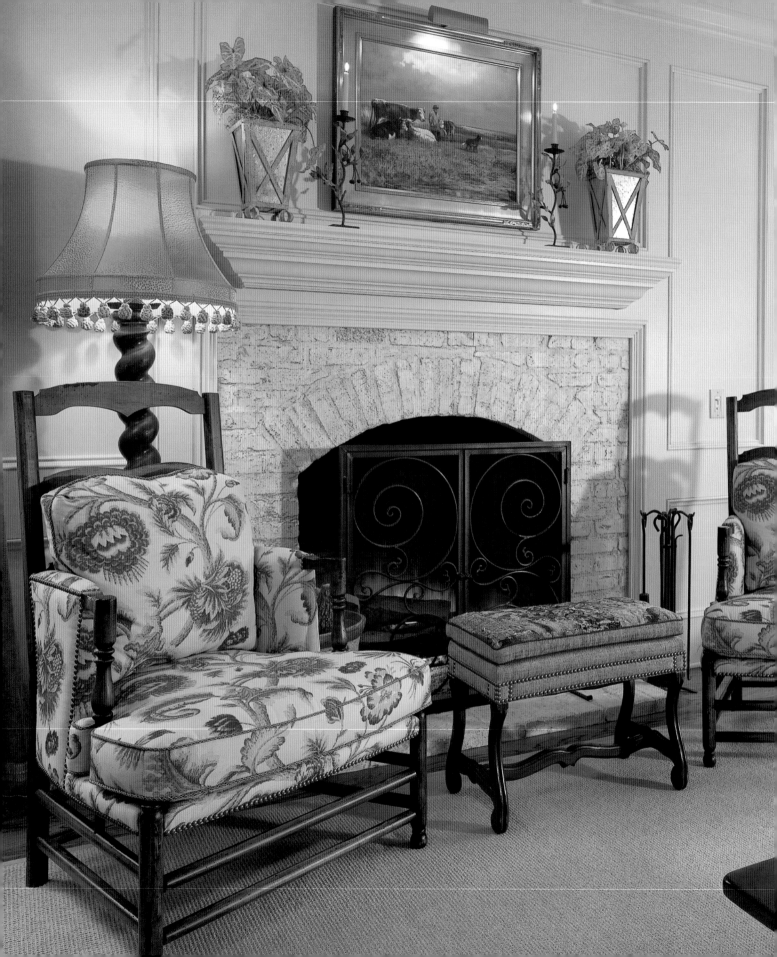

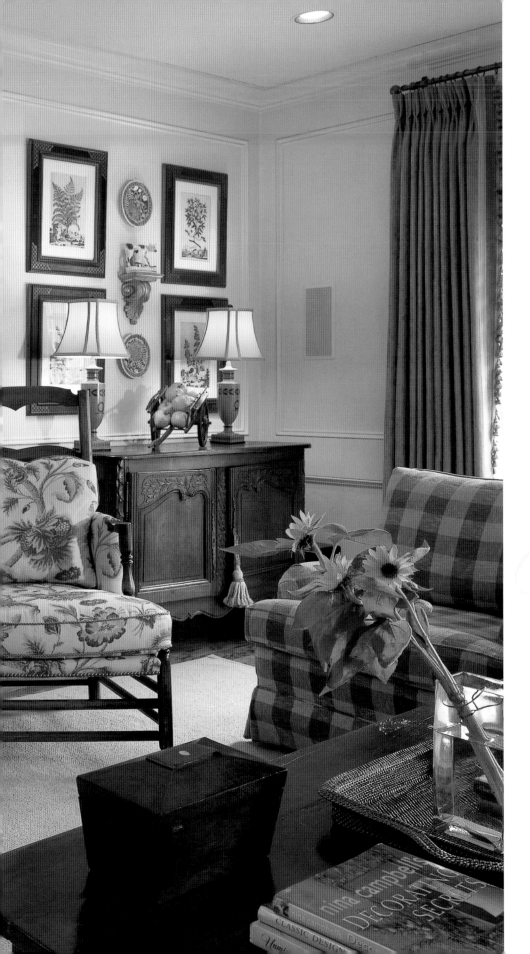

A PAIR OF "Monique" Charles Faudree armchairs covered in hand-painted Bennison fabric adds to the country home atmosphere in Blake and Amy Herndon's family room. A bovine painting above the mantel is flanked by a pair of tole urns.

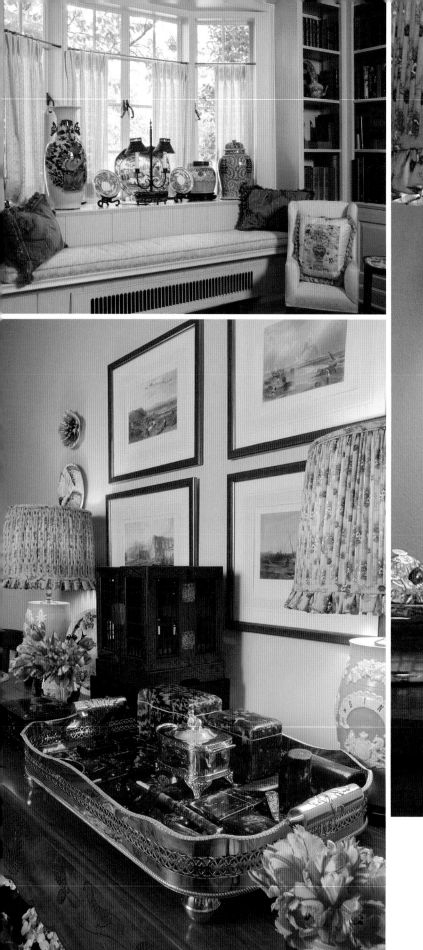
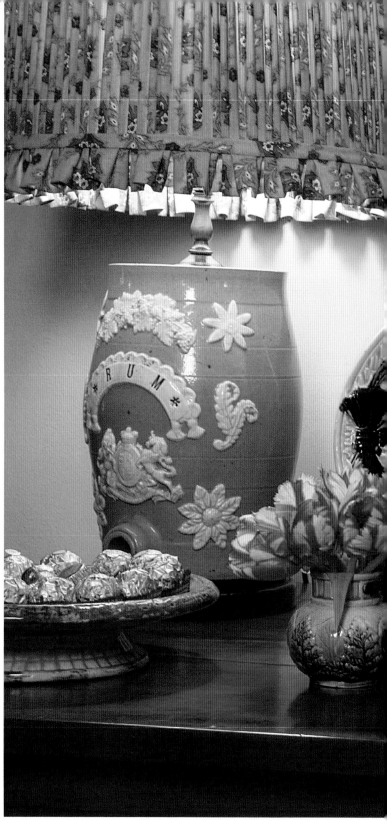

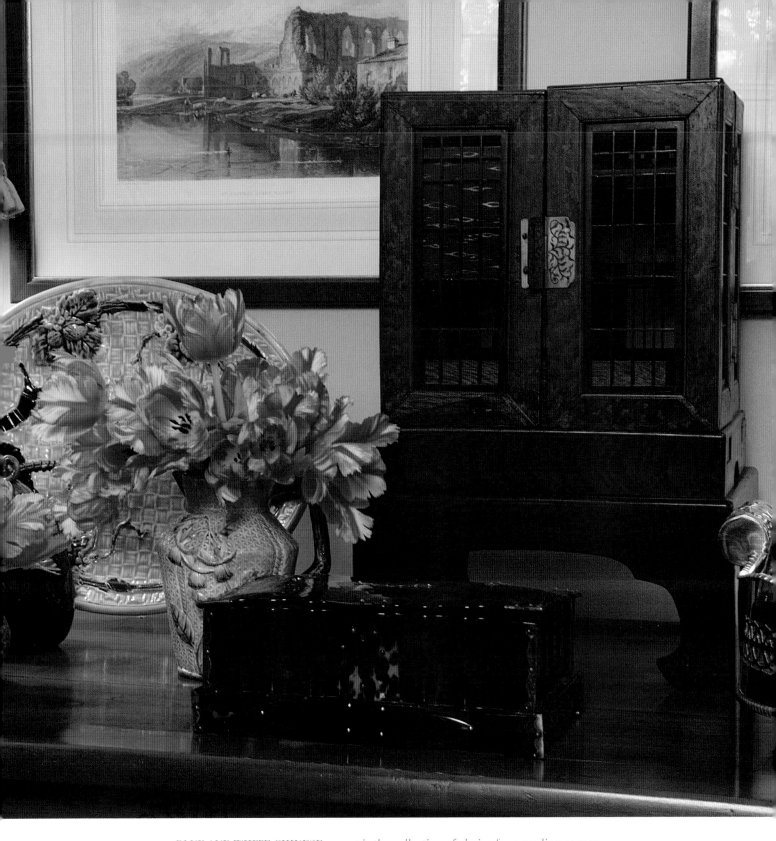

BLUE-AND-WHITE CHINESE export is the collection of choice for a reading corner
in the Franden living room. *facing above*. Even the silver tray bearing the tortoiseshell collection has its own
tortoiseshell lining. *facing below*. Gay parrot tulips accessorize the collection of antiques, *above*.

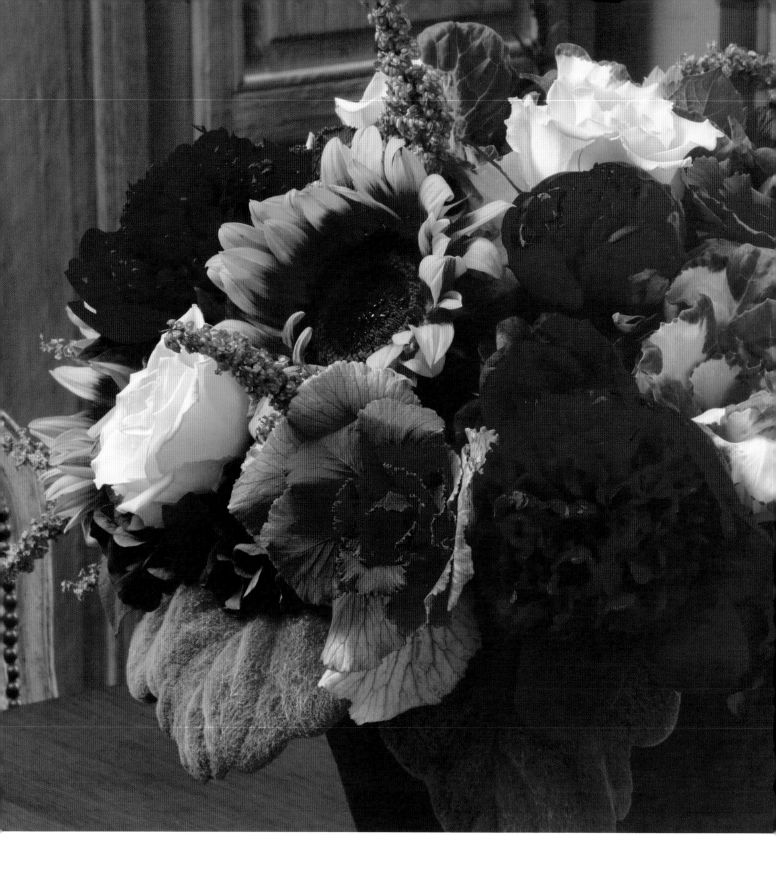

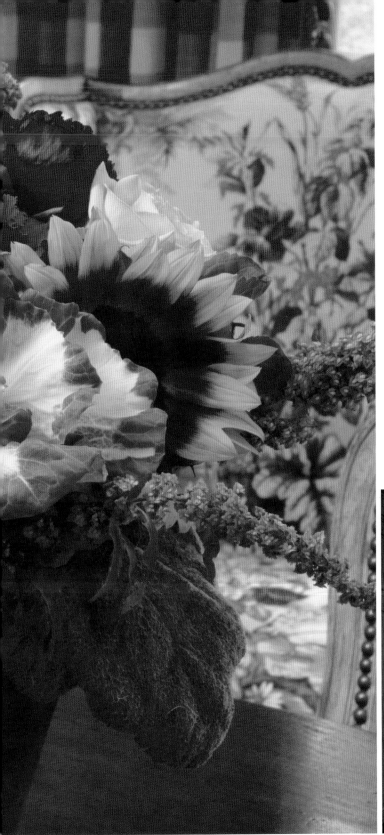

THE SIMPLEST brunch can become an event with the addition of a spectacular arrangement. In a nod to its country kitchen locale, Toni used kale, sunflowers, roses, peonies and dock to repeat colors of the Scalamandré-covered French wing chairs and the Brunschwig & Fils fabric on the dining chairs. Country check curtains are also Brunschwig & Fils.

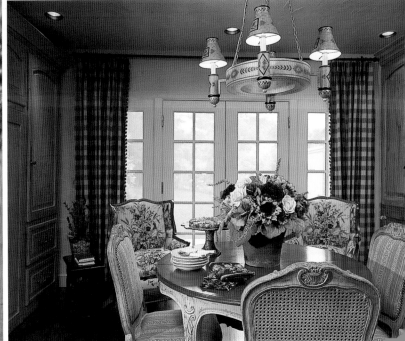

"WHO CAN
DENY THAT PRIVACY
IS A JEWEL?"

—Philippa Tristam

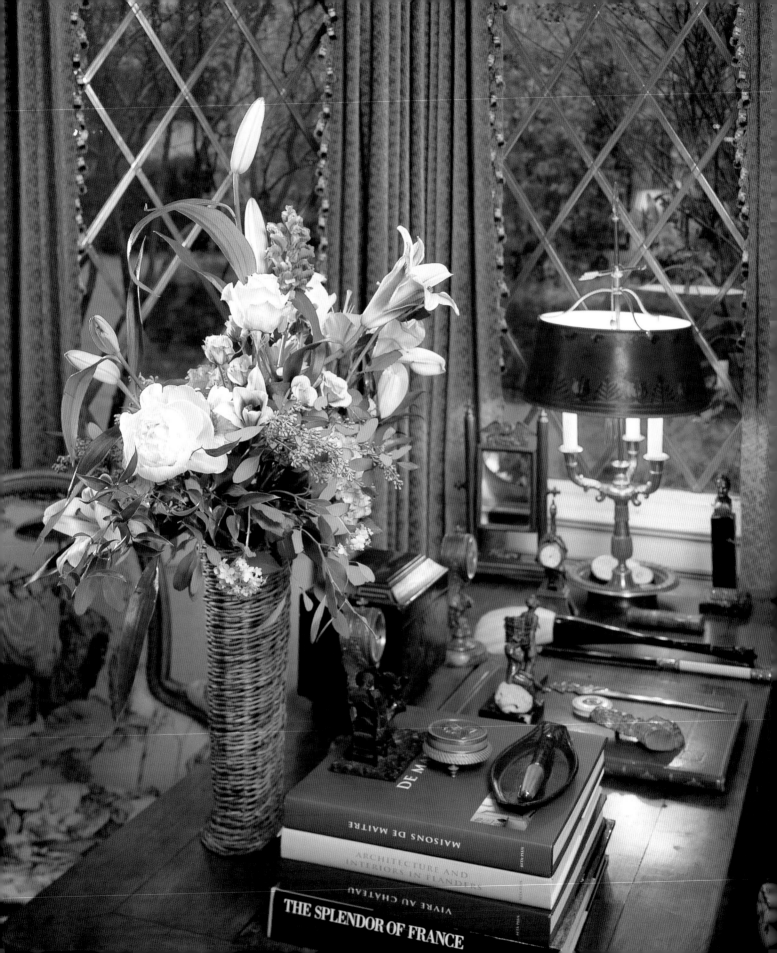

MAISONS DE MAITRE

ARCHITECTURE AND
INTERIORS IN FLANDERS

VIVRE AU CHATEAU

THE SPLENDOR OF FRANCE

ON CHARLES'S
desk, a smart woven
vase found at a
Parisian flower shop
is a pleasing con-
trast to a romantic
spring bouquet. The
desk is also the plat-
form for a collec-
tion of Napoleonic
memorabilia.

FOR MANY PEOPLE—certainly for me—it's very difficult to find
the time to just relax and unwind. Taking time for ourselves al-
ways seems to be at the bottom of the list, so the very least we
can do is devote more, not less, attention to our surroundings in
the spaces where we spend our precious private moments.

Our refuge for private moments deserves a big dose of com-
fort. Chairs should be plump and inviting. If your space is a sitting
room, by all means have a place to put your feet up. Ottomans are
nice. Pillows, all shapes and sizes, invite relaxation.

Private Moments

My bedroom is my main getaway. I've used my favorite fab-
rics and colors there; so no matter how busy I am, I go to bed
and wake up in an atmosphere I really like.

I look forward to early evenings curled up with my dogs
Nicholas and Ruby. It's a cozy, memory-filled room. I have every-
thing from potpourri to pillows to pictures there, and although it
is usually hidden out of sight in my Swedish *buffet deux corps*, I like
to keep the television in this room, too.

In short, my bedroom is my private haven. I enjoy thinking
about what I've done and what I'm going to do tomorrow. I do
my daily meditations there. I take a deep breath and I appreci-
ate my life.

—*Charles*

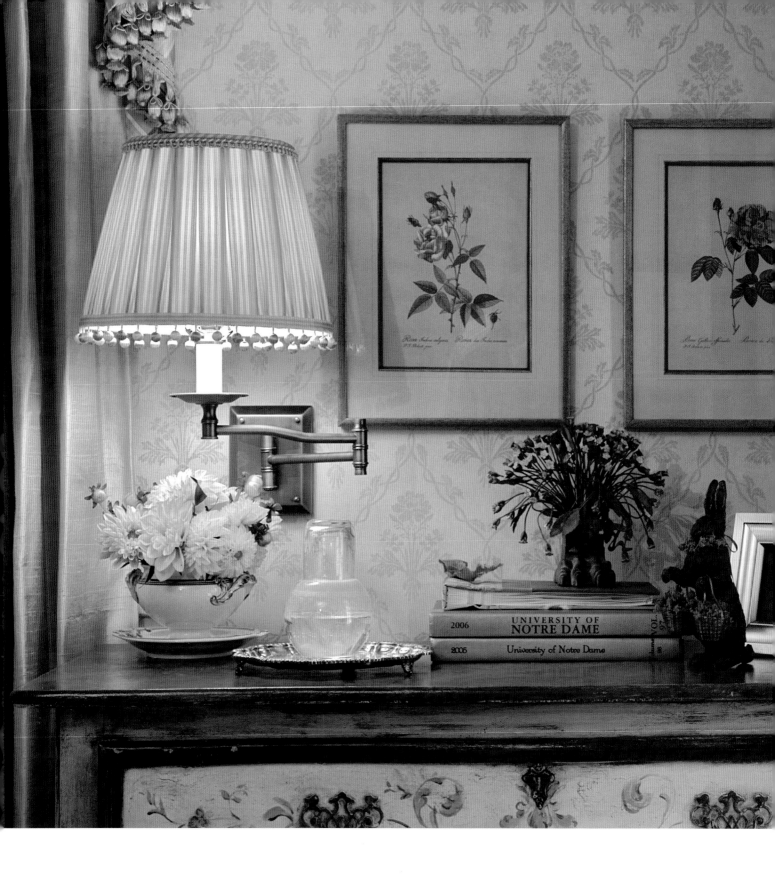

THE SOOTHING blue and green color scheme of Brittany Radcliffe's bedroom was a logical choice for a busy medical student. Lush curtains are in Fabricut fabric and bed dressing fabrics are by Fabricut and Beacon Hill. Bedside commodes are the same Louis XVI style executed in different paint finishes. At the foot of the bed, a childhood favorite Teddy bear reclines against Brittany's college pillow.

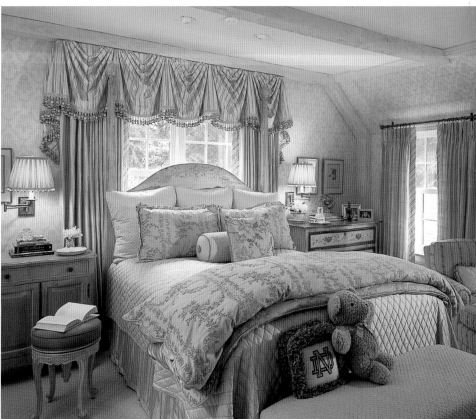

WHEN PORSCHA RADCLIFFE and her sister, Brittany, selected their bedroom furnishings, they opted for different colors that led to equally charming results. Muted pinks in Porscha's room include bed hangings and bed dressing fabrics from Fabricut, S. Harris and Robert Allen. The cream rose nosegay was a memento from Toni marking Porscha's upcoming wedding, *below*. Chairs covered in Bennison fabric flank the fireplace in Porscha's bedroom. On the mantel, Toni's luxuriant rose topiaries continue the floral pink theme of the Zoffany wallpaper, *right*.

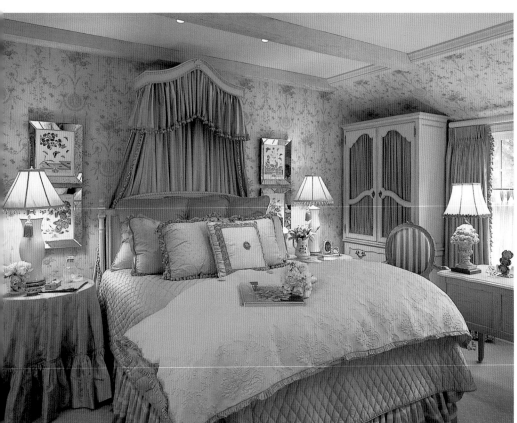

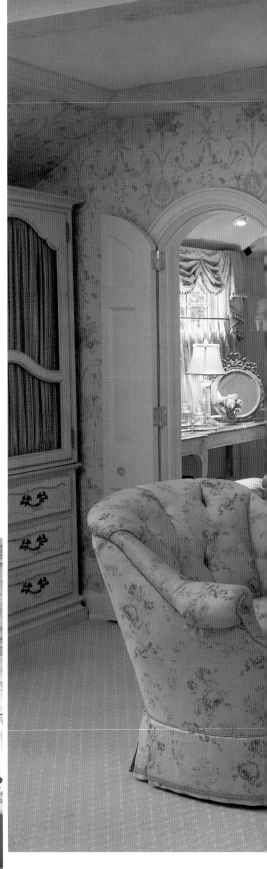

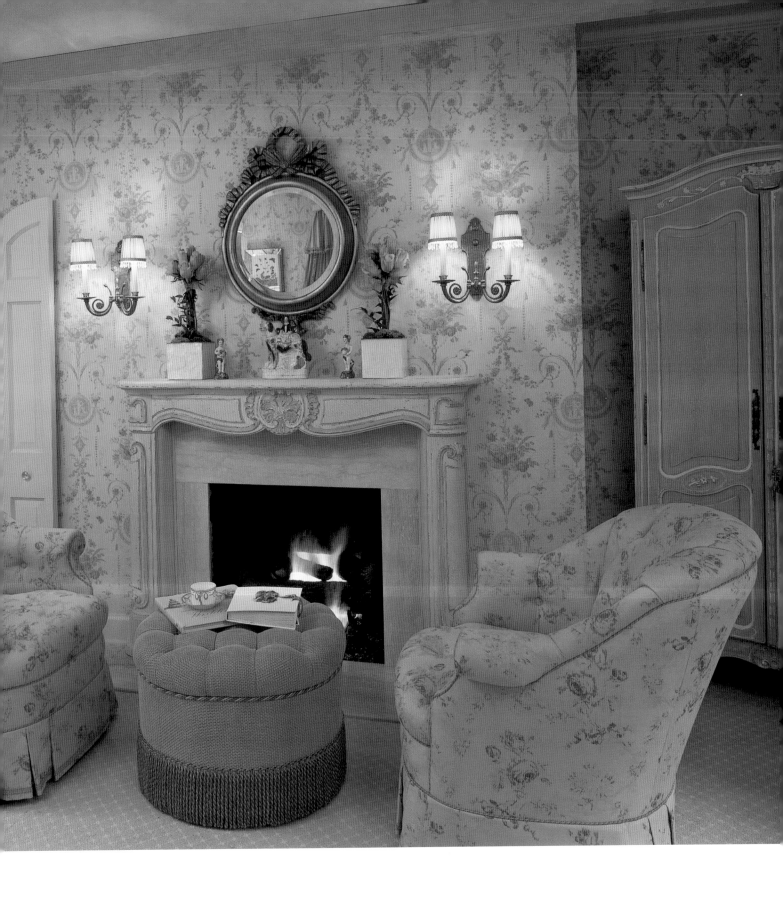

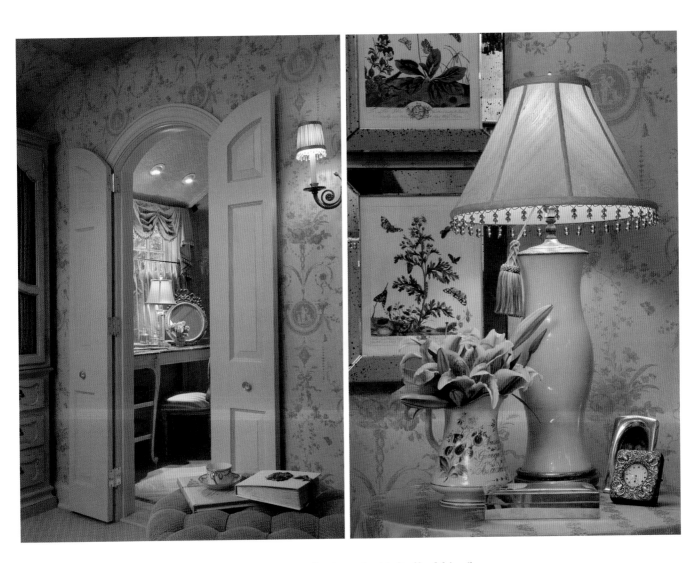

PORSCHA'S MANTEL is adorned with Staffordshire figures.
Topiaries of pink roses are lit by wall lamps with custom silk shades and crystal trim, *facing*.
A glimpse of Porscha's dressing room reveals a small bouquet, a crystal lamp, and a gilt mirror, with
a valance and cafe curtains in Robert Allen's "Premier," *above left*. Botanical prints framed with
mirror and lilies in an antique pitcher add a glamorous touch to the bedside table, *above right*.

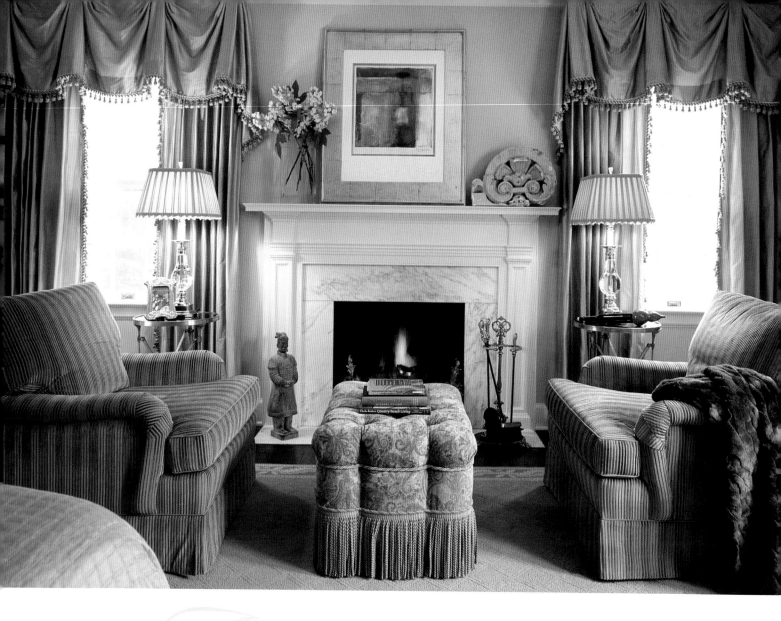

A SIMPLE SPRAY OF OAK leaf hydrangea accessorizes the mantel in the Tucker master bedroom. Dedar-upholstered club chairs and an ottoman covered in velvet paisley by Motif provide fireside comfort. *above*. An antique French wing chair covered in silk by Peter Fasano is paired with a Girondelle table holding a stately orchid. *facing*.

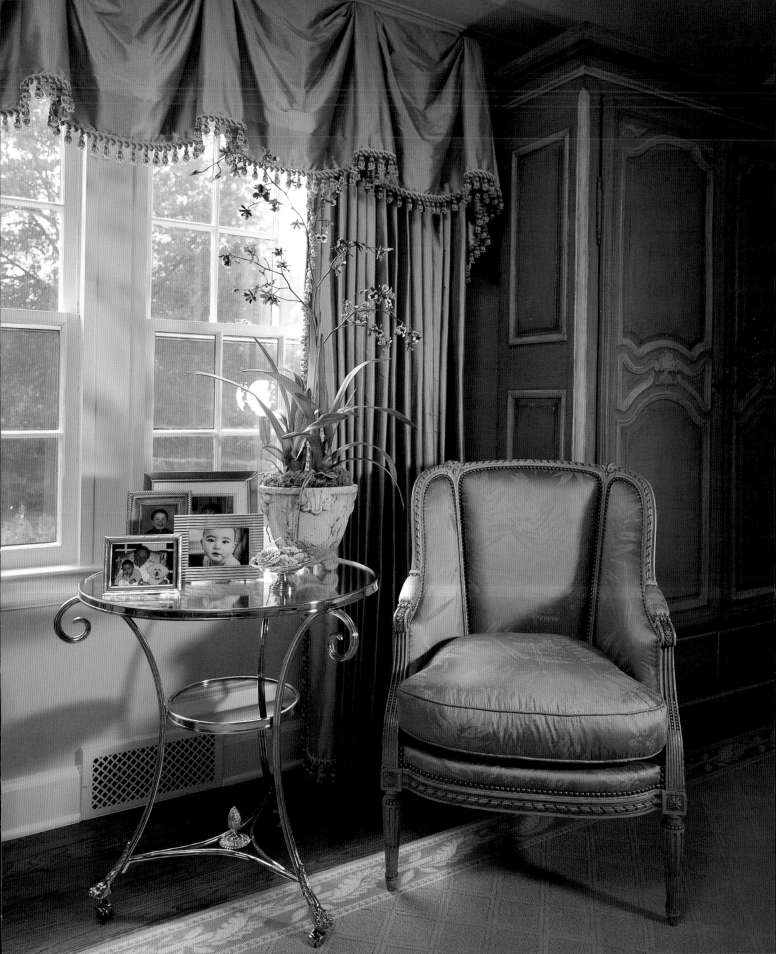

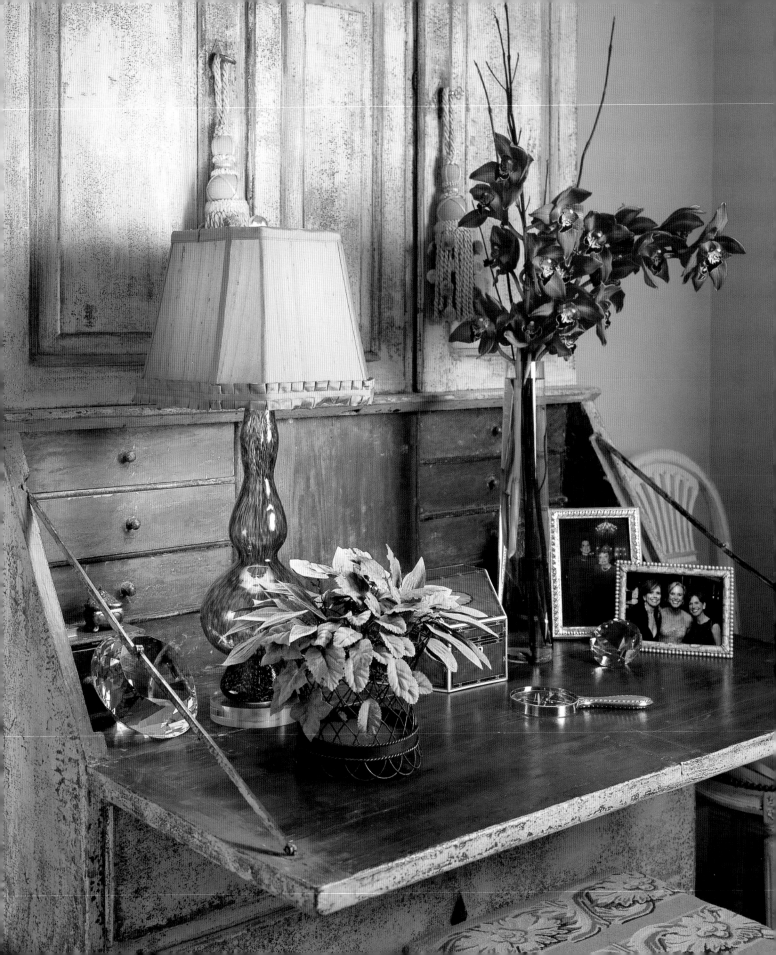

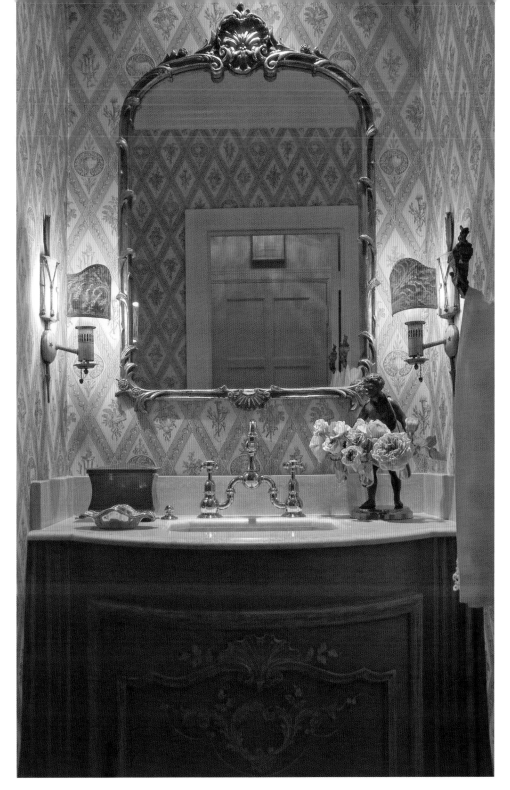

ON A NINETEENTH-CENTURY secretaire from the Gustavian period, a contemporary lamp
with a custom shade illuminates a French zinc leaf bouquet, *facing*. The vanity
in the Tuckers' powder room began with a carved French door that was remodeled into a
cabinet. Shades for the tole sconces complement the wallpaper (discontinued)
from Baker. Abraham Darby roses from the garden in a blackamoor vase and
a red tole box accessorize, *above*.

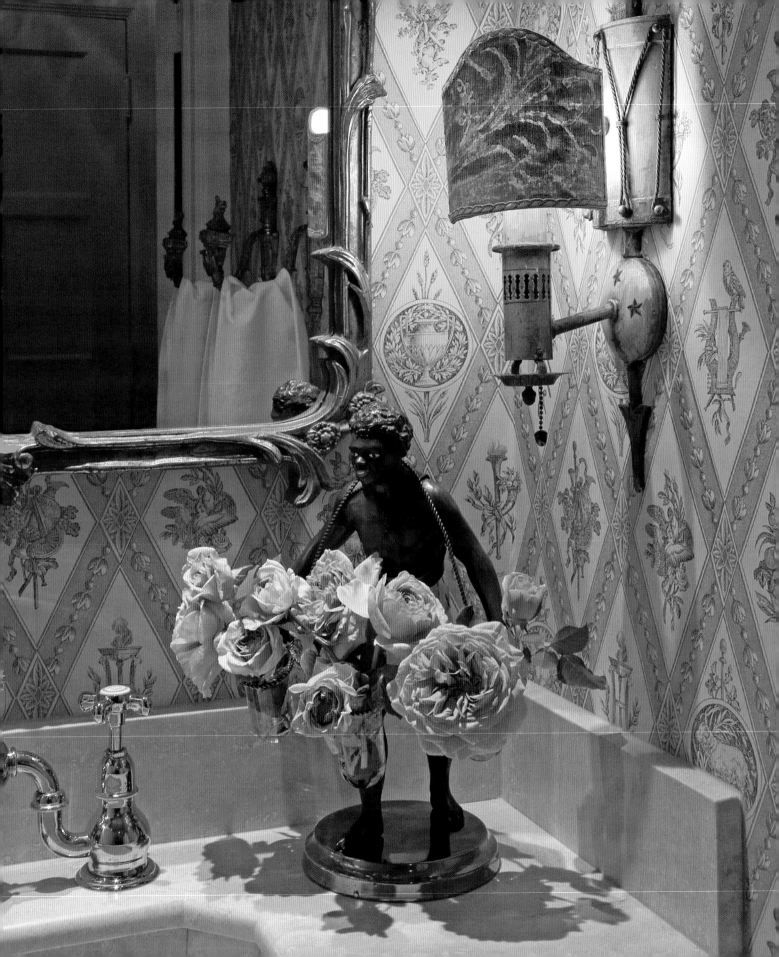

Featuring Unique Containers

I really love to use things my clients already own as the containers for their floral arrangements. The creative result, whether a small nosegay or an elaborate centerpiece, is more personal. Choosing just the right thing from everyday belongings can be an adventure for both of us.

Some containers are obvious candidates. Footbaths are large, beautiful old pieces that can hold substantial arrangements. A pretty casserole that isn't going to be used to serve vegetables is another easy choice. All of your favorite china pieces will work, and crystal stemware is a natural for smaller arrangements.

Unexpected vase adaptations add the bonus of surprise. The thing to remember when you look for an unusual container is that, with a lining of plastic, virtually anything will hold flowers.

—*Toni*

A PAIR OF MARVIC fabric–covered fauteuil armchairs in the Herndons' master bedroom flanks a nineteenth-century Louis XV–style commode from Savoie. A cachepot filled with hydrangeas picks up the color of a pair of rare apothecary powder jars, *above and facing above.* Silk drapes in Highland Court fabric set the mood in the Herndons' master bedroom. Custom shade is in Marvic fabric. Simple vase holds lavender sweet peas. *facing below.*

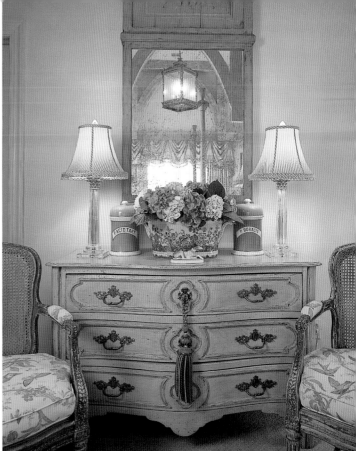

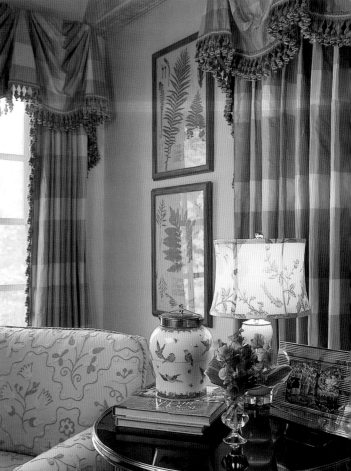

Fabricut fabrics pick
up the color of a celadon lamp in the
Lockard master bedroom.
A custom iron bed and French commode
complete the setting, *below*.
Hydrangea, viburnum and lilac fill a Rose
Medallion bowl, *right*.

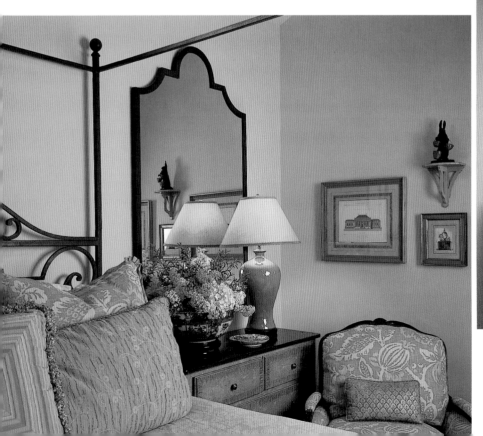

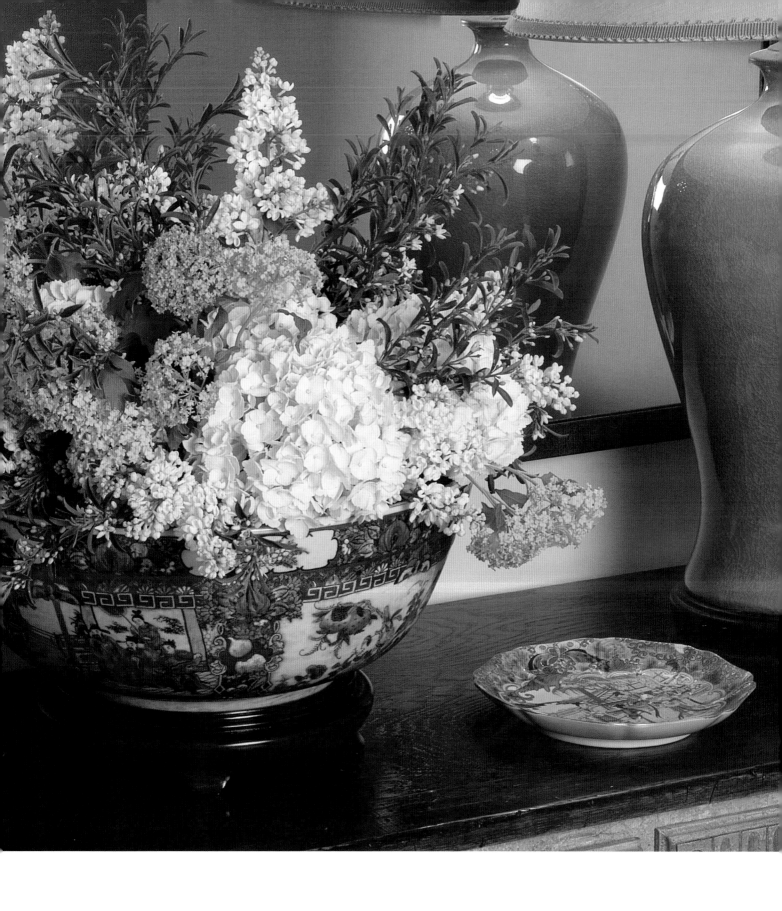

TONI CREATED a living potpourri for this bedroom retreat. Black calla lilies frame scented geraniums. Cymbidium orchids and pink freesia complete the setting, *left* and *below*. A French wing chair covered in Stroheim and Romann "Chow Dynasty" damask and a nineteenth-century French commode create an elegant bedroom corner, *facing*.

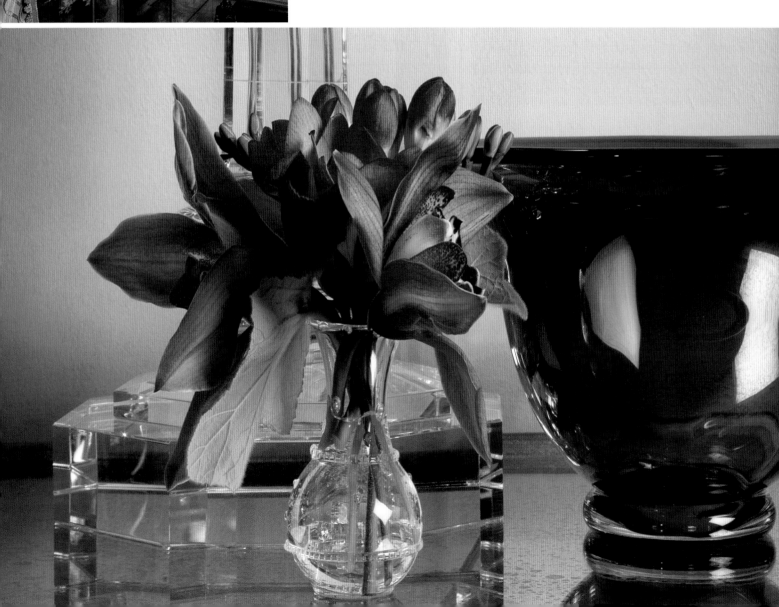

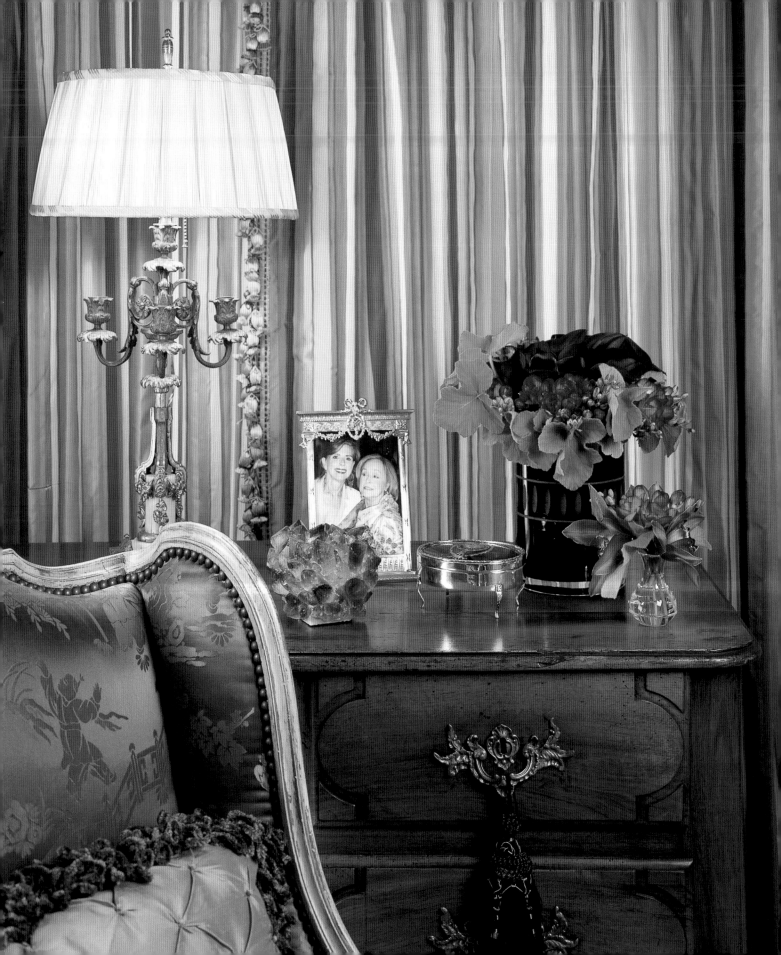

THE MASCULINE feel of stone and glass in the men's powder room is finished with a restrained bouquet of ranunculus, *left*. Swags of Brunschwig & Fils wallpaper "drapery" form the backdrop for a writing table–to–dressing table conversion in the ladies powder room of the Pielsticker home. Toni uses a simple green and white bouquet to echo the Jimmy Steinmeyer botanical above it, *below*.

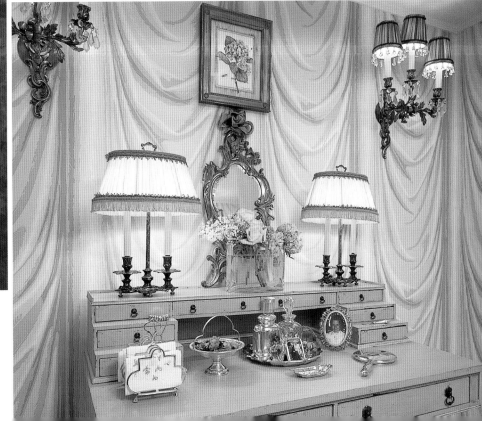

"EARTH
LAUGHS IN FLOWERS"

—Ralph Waldo Emerson

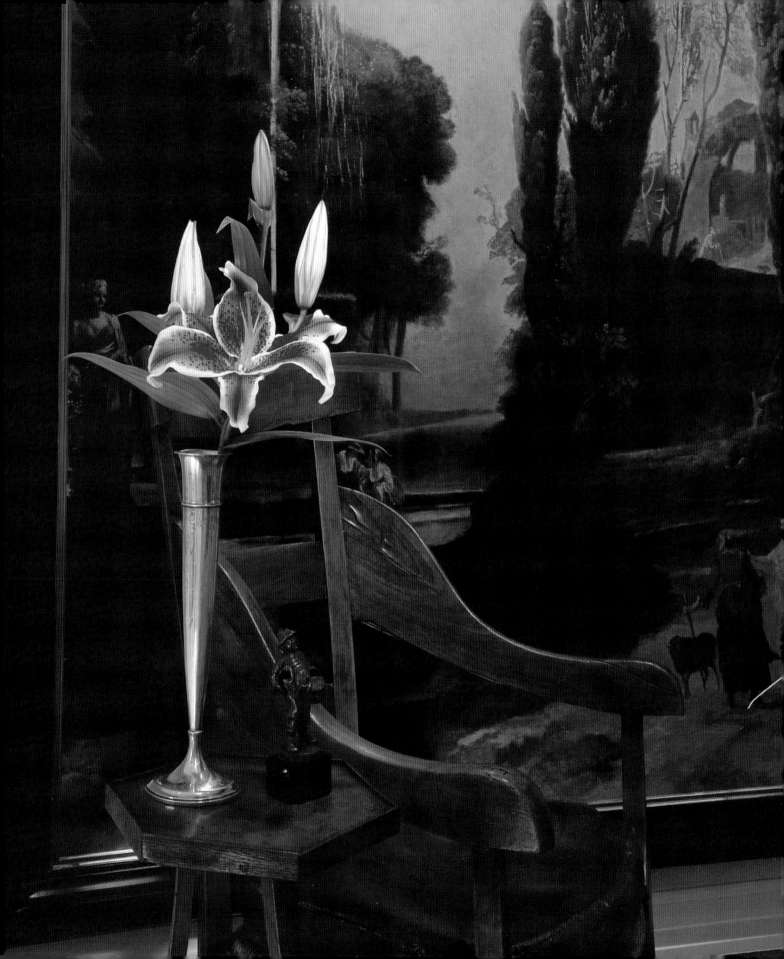

MY FRIEND AND NEIGHBOR Carol Pielsticker has a wonderful rose garden where I am fortunate to have cutting privileges. I like to take a single rose bud and put it on my vanity in something simple—a small vase or a pretty old perfume bottle. Having that one perfect flower to look at when I shave in the morning means as much to me as a $500 bouquet.

Single flowers have a way of calling attention to themselves. Their very simplicity lets you focus on shapes, colors and scents that can get lost in a larger arrangement. And whether it's my old perfume bottle or a rare Lalique vase, individual flowers or clusters of a single type and color show off their containers to best advantage.

The Magic of One Flower

An antique Staffordshire cow is a great accessory, but the addition of a daisy or two to its spill, or vase, calls attention to both. In a contemporary interior, a single imposing blossom of ginger can provide a dramatic accent without overwhelming the clean lines typical of the style. At the other end of the spectrum, a small-scale flower can offer an equally big impact.

I particularly like the pink peony in the Toby jug pictured on page 145. It's a charming container for the peony, which serves two purposes here: it is beautiful in its own right and it also adds a little humor as a fluffy pink "hat" for the antique jug.

—Charles

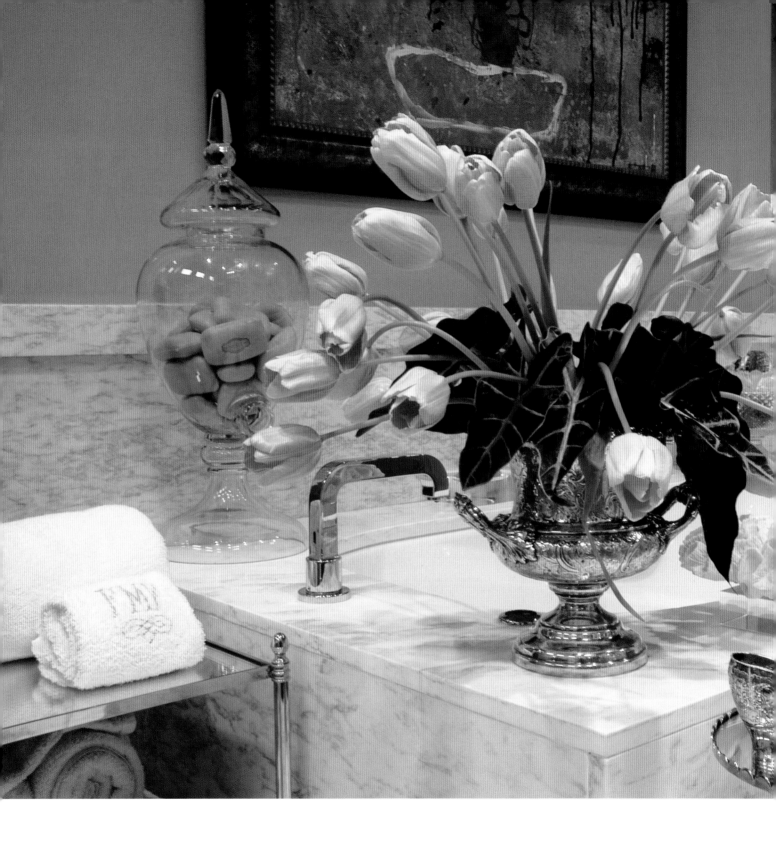

African mask leaves
support pink tulips in a Champagne cooler, *left*.
Pear blossoms from the garden
in a Staffordshire cow spill become a centerpiece
of note when grouped with personal
objects, *below*.

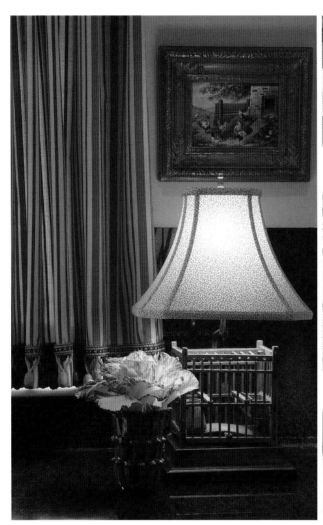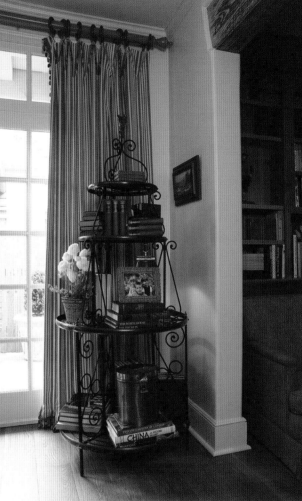

IN THE SIMPSON kitchen, Toni demonstrates that vegetables can rise above culinary duties. Here she uses kale for a fresh, long-lasting arrangement. A small bird carrier is the base for a charming custom lamp, *above left*. Charles Faudree's clients share his expertise, his friendship and even, on occasion, his belongings. An unusual round antique bread rack that once belonged to Charles now marks the library entry of his friend and first paying client, Diane Simpson, *above right*. White ranunculus adds life to a book-filled rack, *facing*.

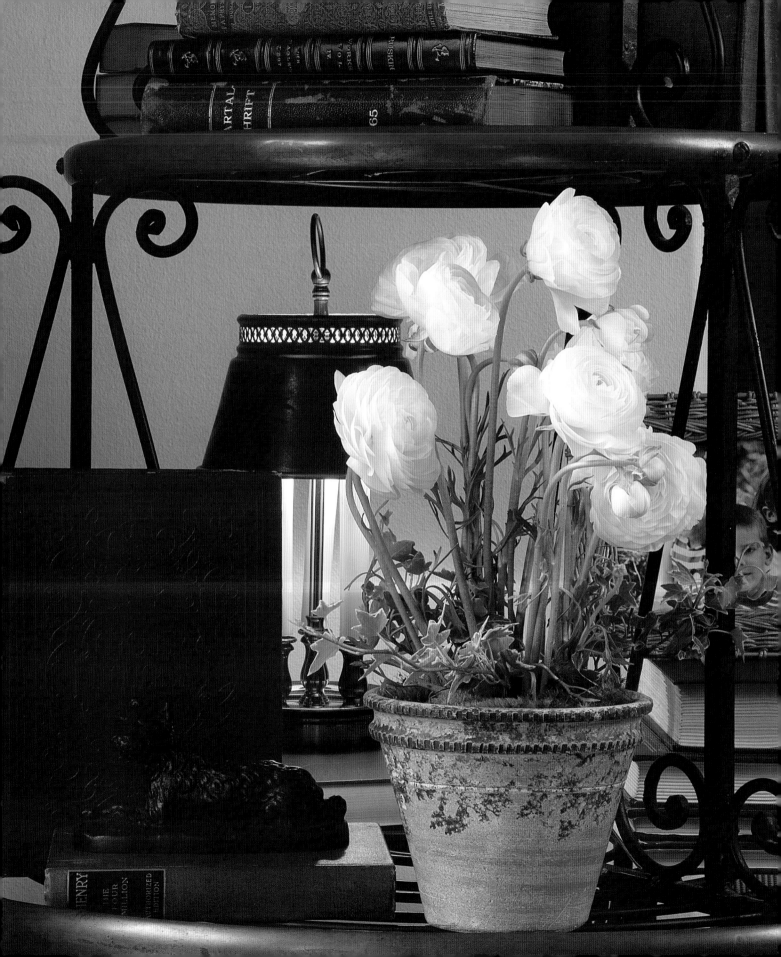

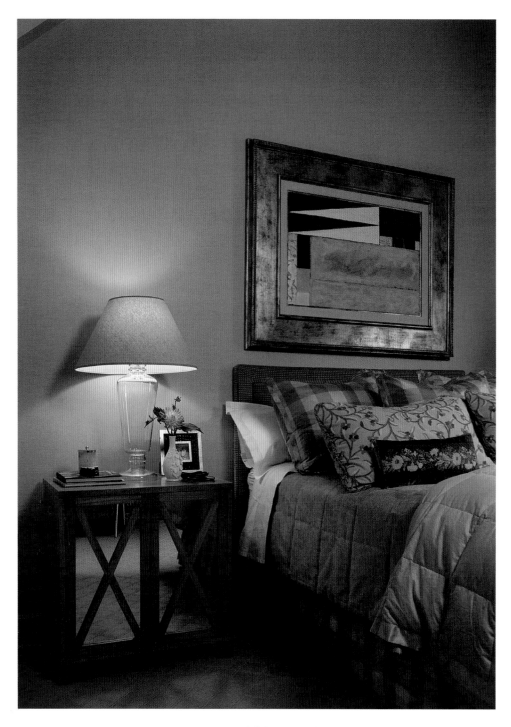

SOOTHING COLORS and fabrics are the hallmark of
this master bedroom. Coverlet by Stroheim and Romann. Custom headboard fabric, Zimmer
Rhode, *above*. A single dahlia brightens the bedside table, *facing*.

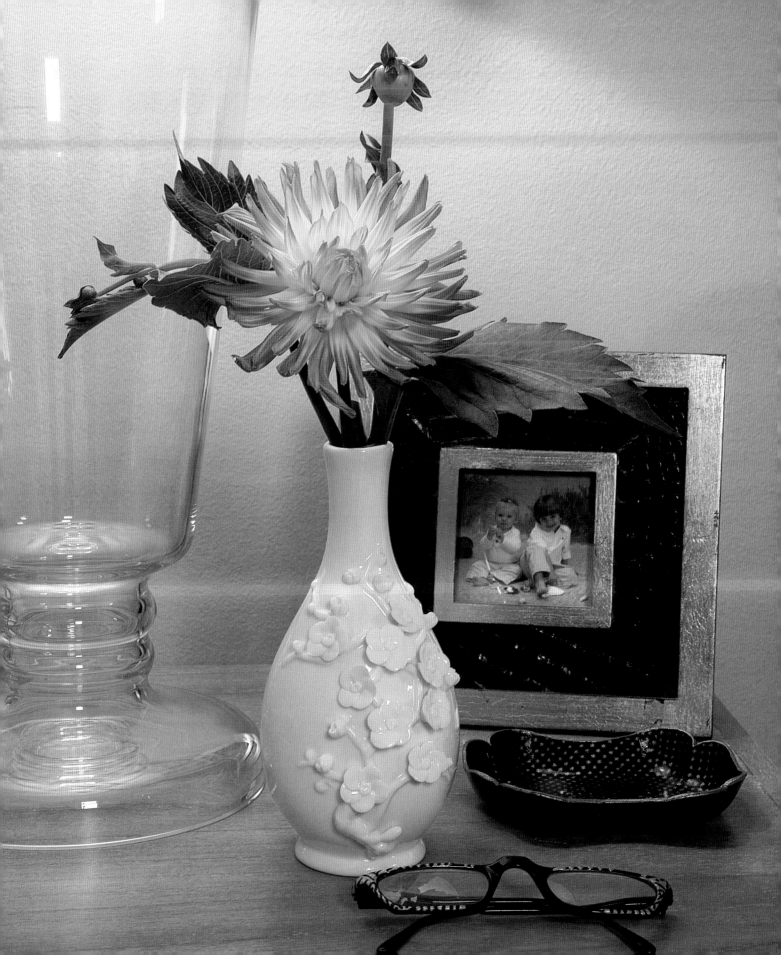

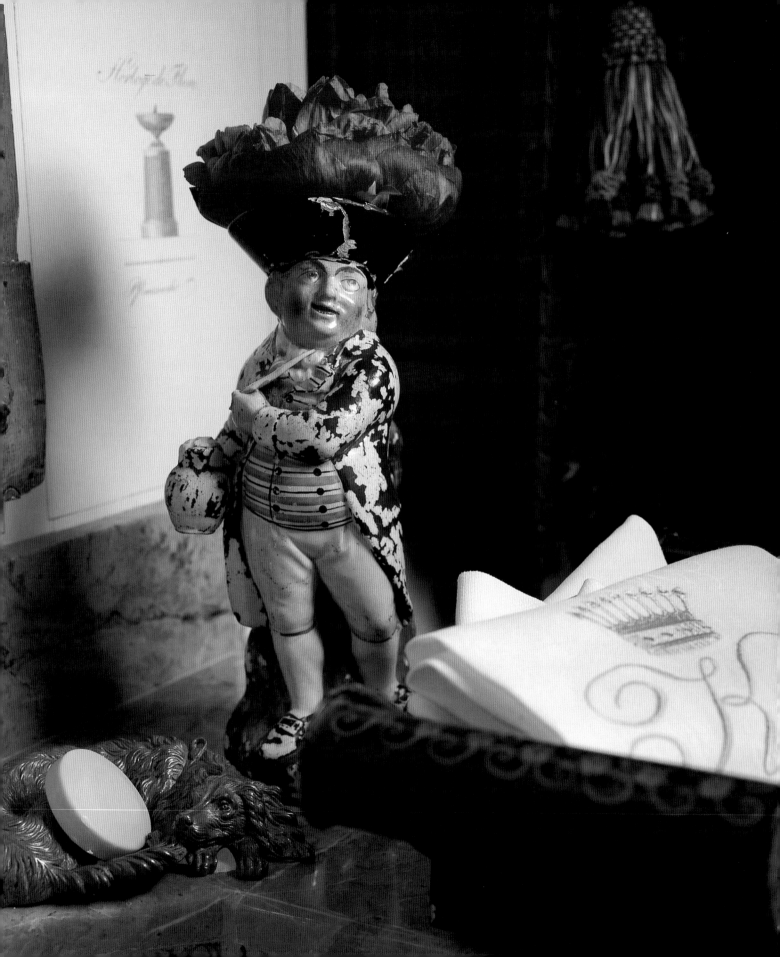

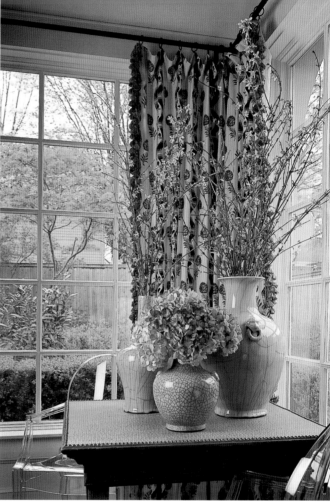

THE MAGIC OF a single flower is magnified by its container. A peony becomes a whimsical hat for a Toby jug in Charles's guest bath, *facing*. An antique majolica umbrella stand is highlighted with the simple addition of holly in Charles's entry, *above left*. Charles uses acrylic Louis Kartell chairs to pair with a painted Swedish game table in an example of the easy relationship possible between contemporary and traditional pieces. Drapery fabric is Brunschwig & Fils "Grilly" cotton print. Toni designed arrangements of forsythia and hydrangea in a trio of celadon vases for a stunning focal point in the room, *above right*.

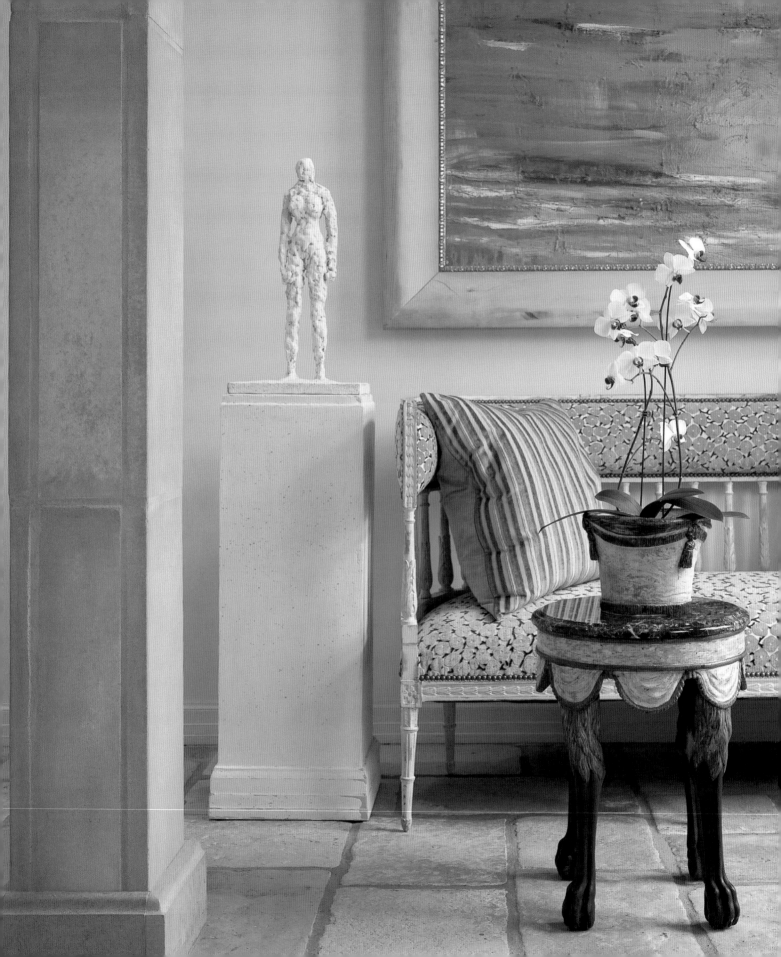

When Less is More

Each flower should be prized for the elegance of its structure and texture. No controversy there. However, perhaps surprisingly, I think the magic of a single flower can also be appreciated even when it is made of silk. Please forgive the pun, but an artificial flower can be your friend though faux.

While I am generally not a silk flower person, I have to admit that the quality of silks is now often botanically correct, both in form and color. And they can be very useful. There's no reason why we can't enjoy the beauty of a flower because we don't have the time to care for it. Many of us are frequent travelers, and the sight of a single lovely flower, an orchid perhaps, can be nice to come home to, even if it is artificial.

I don't think there's a big difference between a gorgeous silk flower and a painting of one. Both evoke memories of the original and both can be enjoyed.

When time is available for pruning spent leaves and refreshing the water frequently, I still cherish the real thing. It's easy to pick up a single stem from your florist or select a particularly stunning blossom from your own yard. Whether from a luscious garden, a window box or a terra-cotta pot, the awe we experience over the beauty of a single bloom or cluster of a single variety enriches our days.

In every respect, flowers should be shared. When you include a single flower in a powder room or guest bedroom, you add more than the magic of one flower: you add your thoughtfulness. Charles's sister, Francie, says when she has houseguests she always offers fresh-squeezed orange juice in the refrigerator and a single fresh blossom on their bedside table. With these gestures, she is expressing her concern for their welfare. Surely there's magic in that.

—Toni

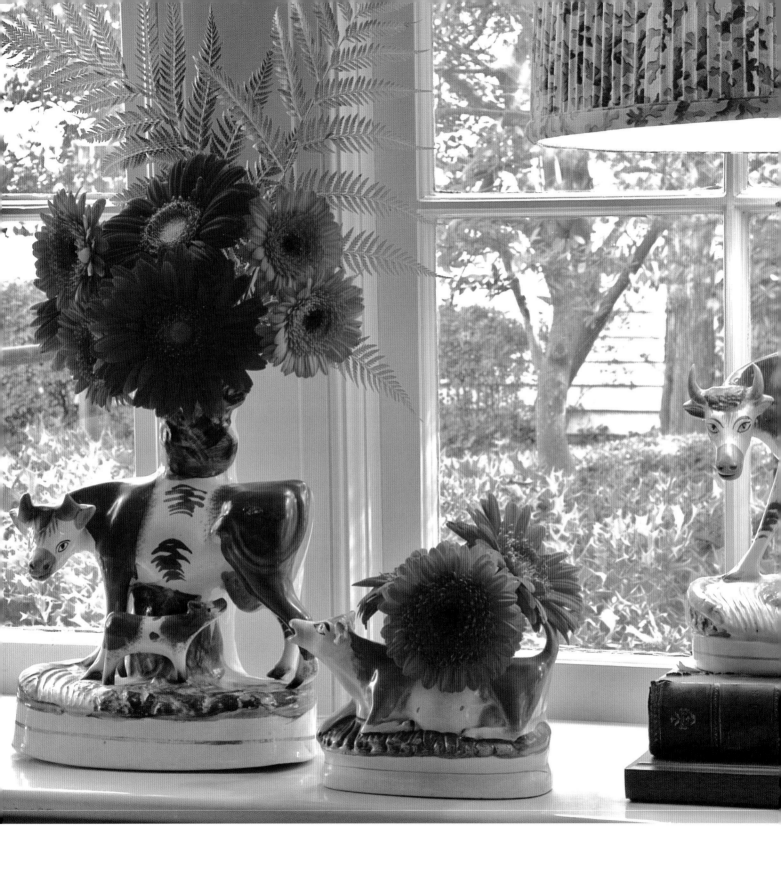

Library windows
in the Franden home overlook a
wooded garden that
inspired the use of leafy
Brunschwig & Fils draperies.
The pastoral setting
is an ideal location for a collection of
Staffordshire cows whose
spills are filled with bright
gerbera daisies.

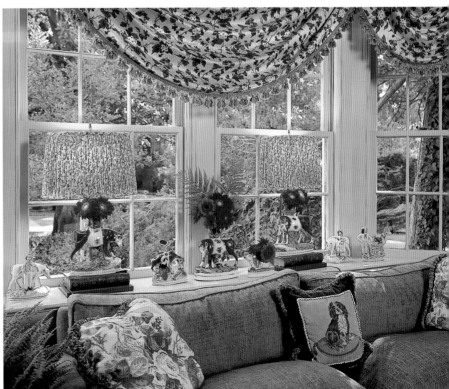

AN INTERNATIONAL cast of furnishings sets the stage for entertaining in the Faudree/Gillman dining room. A bronze-and-crystal chandelier hangs above an iron-and-glass table made of antique elements. The vase began life as a Japanese ceremonial hibachi pot. An eighteenth-century Italian statue, originally an opera stage piece, completes the merry mix, *below*. Toni likes to show off flowers' natural beauty without restraint by wire or florist picks. Here, Flamingo tulips create a smashing centerpiece, *right*.

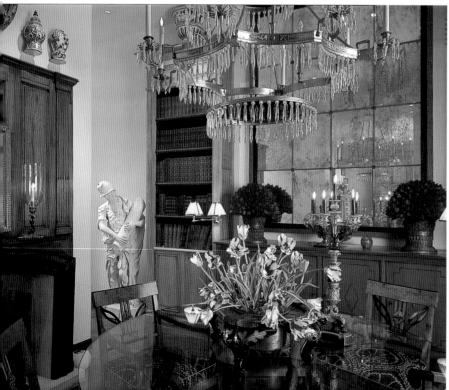

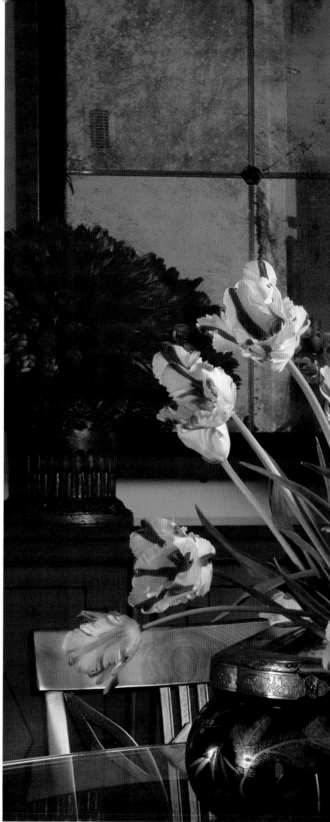

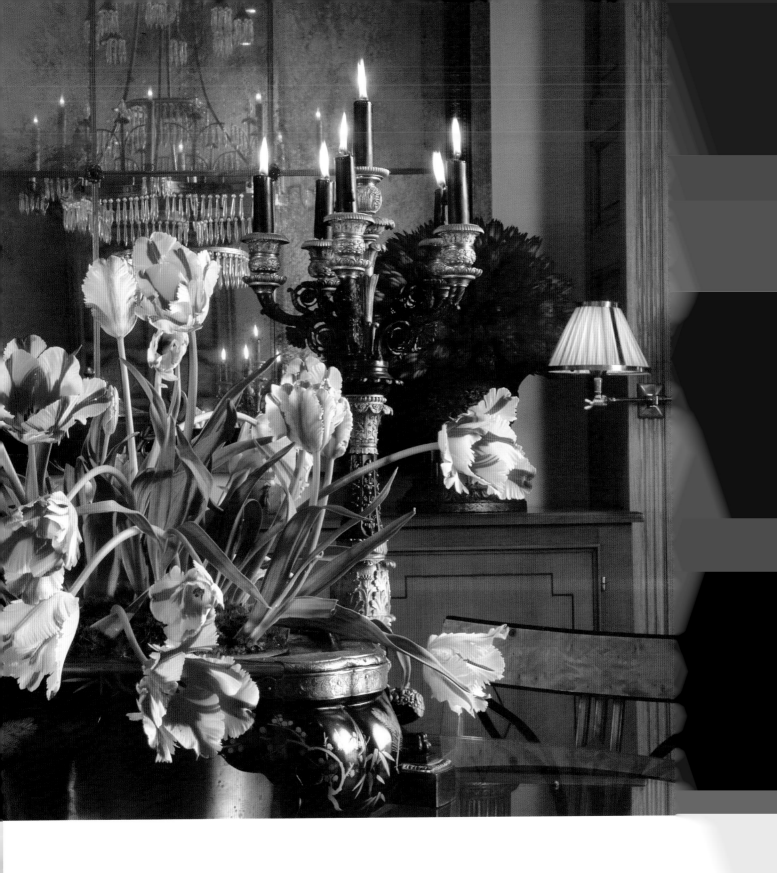

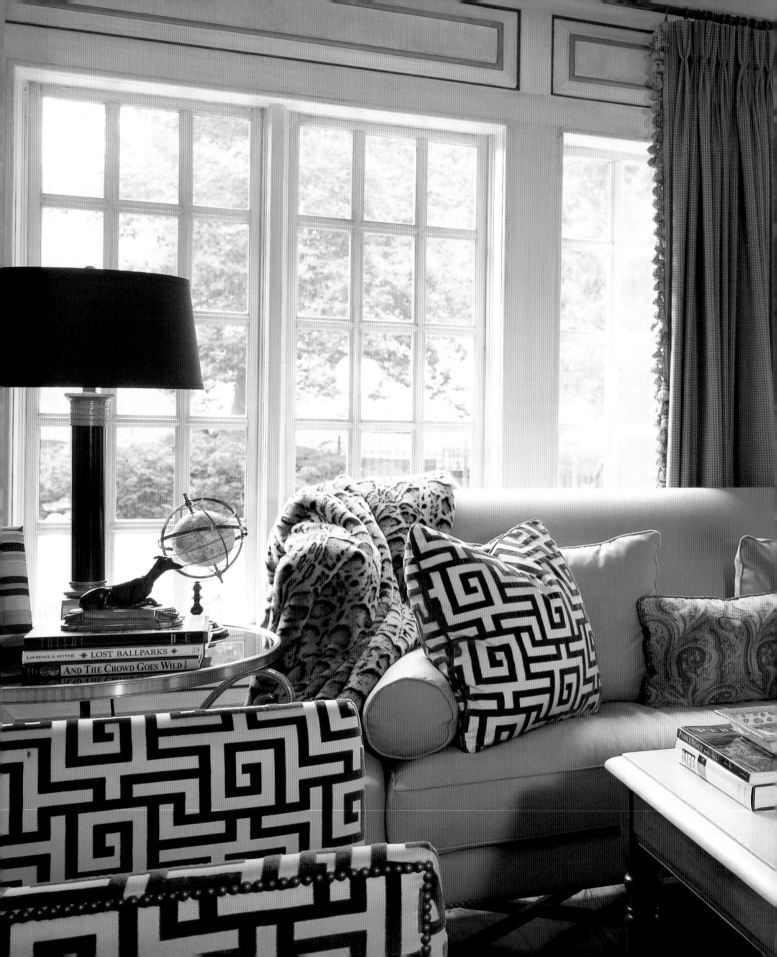

LOST BALLPARKS

LAWRENCE S. RITTER

AND THE CROWD GOES WILD

PEBBLE BEACH

PUB

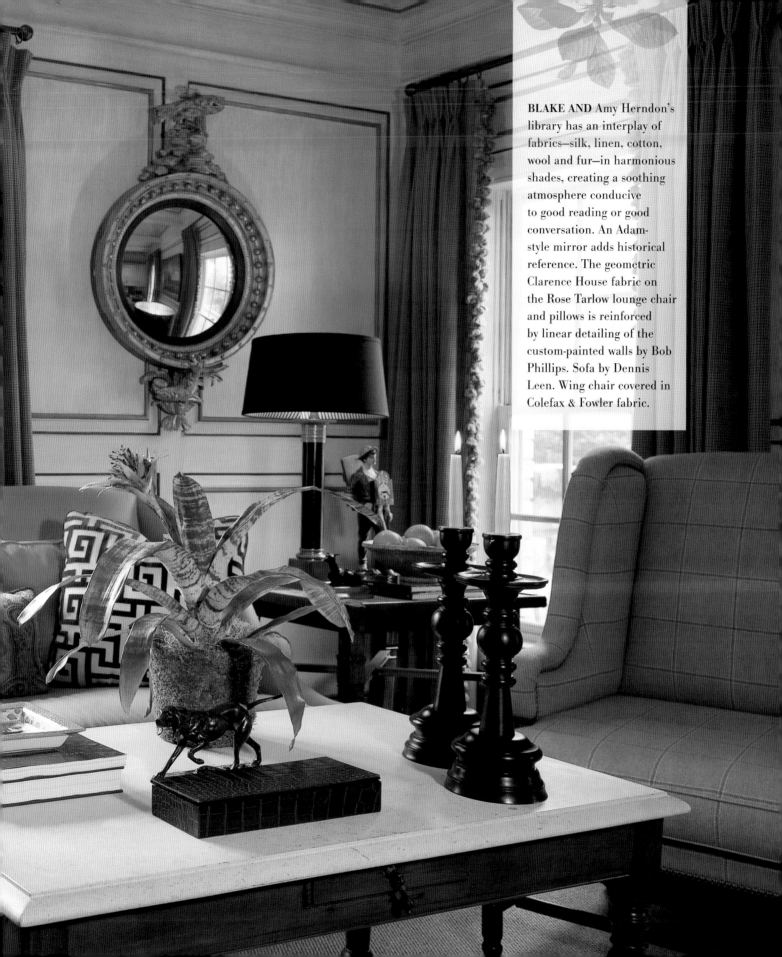

BLAKE AND Amy Herndon's library has an interplay of fabrics—silk, linen, cotton, wool and fur—in harmonious shades, creating a soothing atmosphere conducive to good reading or good conversation. An Adam-style mirror adds historical reference. The geometric Clarence House fabric on the Rose Tarlow lounge chair and pillows is reinforced by linear detailing of the custom-painted walls by Bob Phillips. Sofa by Dennis Leen. Wing chair covered in Colefax & Fowler fabric.

A PAIR OF ANTIQUE bronze lamps, formerly vases, light an Imari
bowl filled with French roses in the Franden entry.

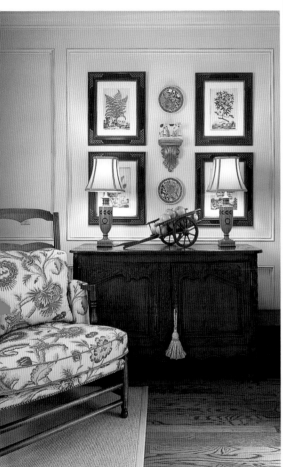

THE COUNTRY ease established by a Louis XV Provençal buffet, tole lamps and Bessler botanical prints is emphasized by an apple-filled antique wagon in lieu of flowers.

AN ANTIQUE CHEST, a Chinese painting and a stone bouquet transform a small wall into a charming focal point in the Simpson home. Yellow cymbidium tops an eighteenth-century Dutch commode.

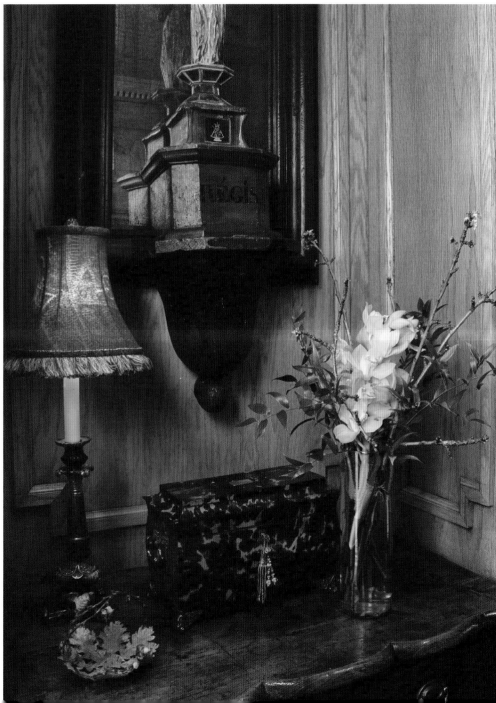

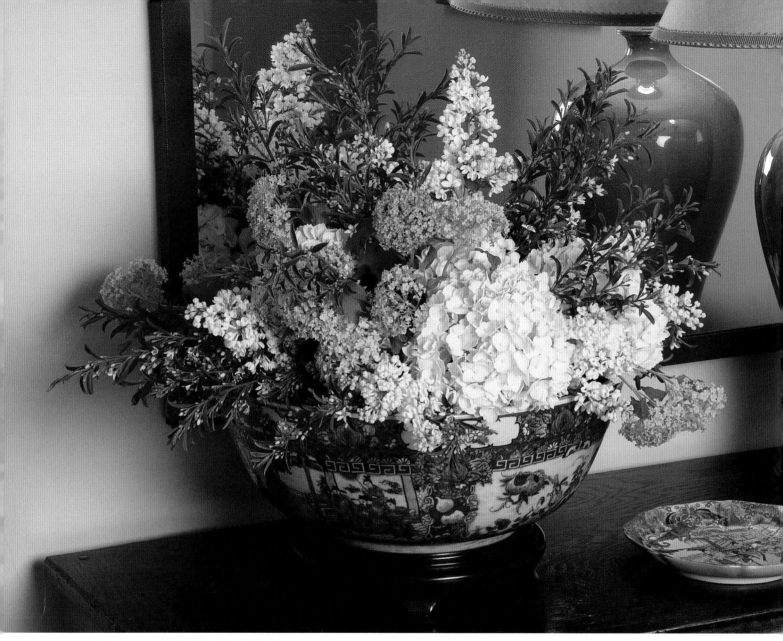

ACKNOWLEDGEMENTS

What a pleasure and honor to work with talented and gifted people, especially when they are dear friends and as enthusiastic and fun as Francesanne Tucker, our writer, and Rick Stiller, our photographer. Thank you for being part of our team.

We also thank our clients and wonderful friends for their generosity in sharing their beautiful homes. We are ever so grateful to each of them for making this book possible: Earlene Foster, Gina and Bob Franden, Francie Faudree and Dale Gillman, Amy and Blake Herndon, Sally and Tom Hughes, Kathryn and John Lockard, Julie and John Nickel, Carol Pielsticker, Jennifer and Mark Ratcliffe, Dianne Simpson and Francesanne and John Tucker.

Our staffs have been essential to the process. Their devotion and dedication to this undertaking is most appreciated.

Thanks and more thanks to everyone at Gibbs Smith, and a very special thank-you to Madge Baird, our wonderful, helpful and very talented editor and friend.

— *Charles and Toni*

RESOURCES

I shop everywhere I go, especially at antiques and specialty stores. Here are some of my favorite venues for accessories. It goes without saying that this list would include the Paris flea market, Marché Aux Puces and the English fairs, especially the King's Road Saturday street fair.

CALIFORNIA

JEFFERIES, LTD
852 Production Place
Newport Beach, CA 92663
949.642.4154

ANN DENNIS DESIGNS
2915 Redhill Ave., Suite B 106–7
Costa Mesa, CA 92626
714.708.2555

KATHLEEN STEWART AT HOME
338 N. La Brea Ave.
Los Angeles, CA 90036
323.931.6676

TERRA COTTA
11922 San Vicente Blvd.
Los Angeles, CA 90049
310.826.7878

TOM STANSBURY ANTIQUES
466 Old Newport Blvd.
Newport Beach, CA 92663
949.642.1272

VILLA MELROSE
6061 W. Third St.
Los Angeles, CA 90036
323.934.8130
Also in Corona del Mar

UNIQUITIES
11740 San Vicente Blvd.
Los Angeles, CA 90049
310.442.7655

HOLLYHOCK
817 Hilldale
West Hollywood, CA 90069

FORMATIONS
Dennis and Leen
8720 Melrose Place
Los Angeles, CA 90069
310.659.3062

GEORGIA

BOXWOOD GARDEN AND GIFTS
1002 E. Andrews
Atlanta, GA 30305
404.233.3400

JANE MARSDEN
2300 Peachtree Road, N.W.
Atlanta, GA 30309
404.355.1288

B.D. JEFFRIES
3736B Roswell Road
Atlanta, GA 30342
404.281.3004

NEW YORK

JOHN ROSSELLI ANTIQUES
525 East 73rd St.
New York, NY 10021
212.772.2137

HERBERT DEFORGE
220 E. 60th St.
New York, NY 10022
212.677.3917

PIERRE DEUX
979 Third Ave., Suite 134
D & D Building
New York, NY 10022
212.644.4891

NORTH CAROLINA

THE COUNTRY HOME
5162 U.S. Highway 64 East
Highlands, NC 28741
828.526.9038

RUSTICKS
32 Canoe Place
Cashiers, NC 28717

CATBIRD SEAT
551 Highway 107 South
Cashiers, NC 28717
828.743.6565

VIVIANNE METZGER ANTIQUES
31 Canoe Place
Cashiers, NC 28717
828.743.0642

RYAN AND COMPANY
137 Highway 107 North
Cashiers, NC 28717
282.743.3612

DOVETAIL
252 Highway 107 South
Cashiers, NC 28717
828.873.1800

FLETCHER & LEE
417 North 4th St.
Highlands, NC 28741

NEAL JOHNSON LTD
601 S. Cedar St., Suite 205
Charlotte, NC 28202

B.D. JEFFRIES
6809 Phillips Place Court, Suite A
Charlotte, NC 28210
704.556.0019

OKLAHOMA

BEBE'S
6480 Avondale Dr.
Nichols Hills, OK 73116
405.843.8431

THE ANTIQUARY
1323 E. 15th St.
Tulsa, OK 74120
918.582.287

SAM SPACEK
8212 E. 41st St.
Tulsa, OK 74145
918.627.3021

COLONIAL ANTIQUES
1740 S. Harvard
Tulsa, OK 74112
918.143.6700

POLO LODGE ANTIQUES
8250 E. 41st St.
Tulsa, OK 74145
918. 622.3227

T.A. LORTON
1345 E. 15th St.
Tulsa, OK 74120
918.743.1600

ANTIQUE WAREHOUSE
Dale Gillman
2406 E. 12th St.
Tulsa, OK 74104
918.592.2900

CISAR-HOLT
1609 E. 15th St.
Tulsa, OK 74120
918.592.3080

TONI'S FLOWERS AND GIFTS
3525 S. Harvard Ave.
Tulsa, OK 74135
918.742.9027

COVINGTON ANTIQUE MARKET
7100 North Western Ave.
Oklahoma City, OK
405.842.3030

TENNESSEE

CATHERINE HARRIS
2115 Merchants Row
Germantown, TN 38138
901.753.0999

SHEA DESIGN FRENCH COUNTRY
6225 Old Poplar Pike
Memphis, TN 38119
901.682.2089

LA MAISON
4768 Poplar Ave.
Memphis, TN 38117
901.537.0009

TEXAS

BRIAN STRINGER
2031 West Alabama
Houston, TX 77098
713.526.7380

THE WHIMSEY SHOP
1444 Oak Lawn Ave.
Dallas, TX 75207
214.745.1800

KAYE O'TOOLE ECCENTRICITIES
1921 Westheimer Rd.
Houston, TX 77098

JOYCE HORN
1008 Wirt Rd.
Houston, TX 77055
713.688.0507

THE GRAY DOOR
1809 West Gray St.
Houston, TX 77019
713.521.9085

WATKINS CULVER
2308 Bissonnet St.
Houston, TX 77005
713.529.0597

INESSA STEWART
Lovers Lane at Inwood
Dallas, TX 75209
214.366.2660

THE MEWS
1708 Market Center Blvd.
Dallas, TX 75207
214.748.9070

UNCOMMON MARKET
2701 Fairmont
Dallas, TX 75201
214.871.2775

COUNTRY FRENCH INTERIORS
1428 Slocum St.
Dallas, TX 75207
214.747.4700

PIERRE DEUX
1525-A Hi Line Dr., Suite C
Dallas, TX 75027
214.749.7775

NEAL AND COMPANY
4502 Greenbriar St.
Houston, TX 77005
713.942.9809

CHATEAU DOMINGUE
3615 W. Alabama St.
Houston, TX 77027
713.961.3444